Embroidery Techniques
Using Space-Dyed Threads

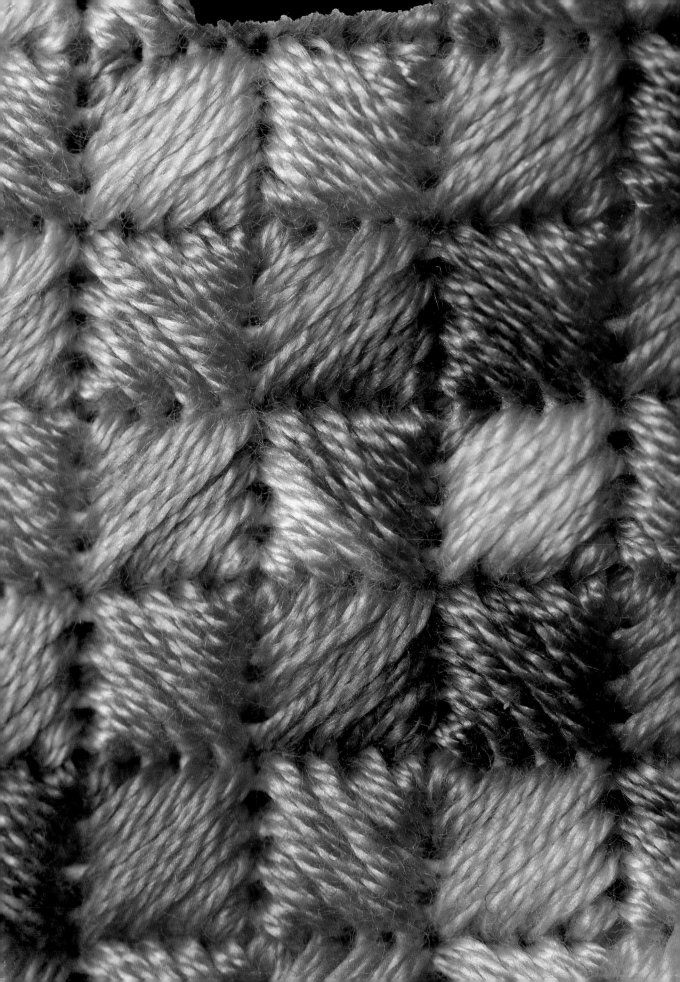

Embroidery Techniques Using Space-Dyed Threads

via laurie

Search Press

Acknowledgements

I could never have written this book without the support of some very special people. Many thanks to the following people:

My dear friend and colleague Leonette, for taking care of Chameleon Threads while I was in front of the computer. Thank you also for being such a good critic and sounding board with each project, as I truly value your opinion. It is a privilege to work with you.

My special friends Di van Niekerk, Gay Booysen and Elsa le Roux, I so appreciate your contributions to this book. Thank you for taking time out of your busy schedules, because without your help I would not have finished on time.

Many thanks also to John Roux, Tricia Elven Jensen, Myrna Stigling and my mom, Sylvia du Plessis for allowing me to use their beautiful work. Thank you to Werner Etsebet for doing the blackwork and canvas work designs on the computer, to Lynn Laver for her help with the Hardanger design, and to Klara-Marie den Heijer, a huge thanks for all your beautiful illustrations.

To my husband and son (the two Roberts), thank you for going off on your own many week-ends so that I could work. Lastly thank you to my Heavenly Father for giving me a creative spirit.

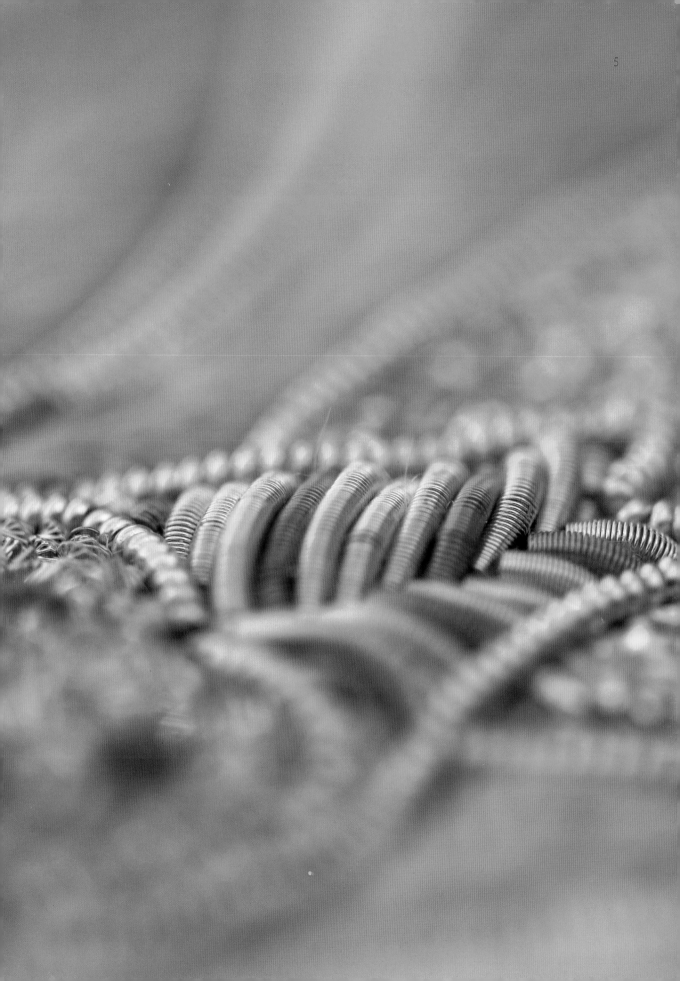

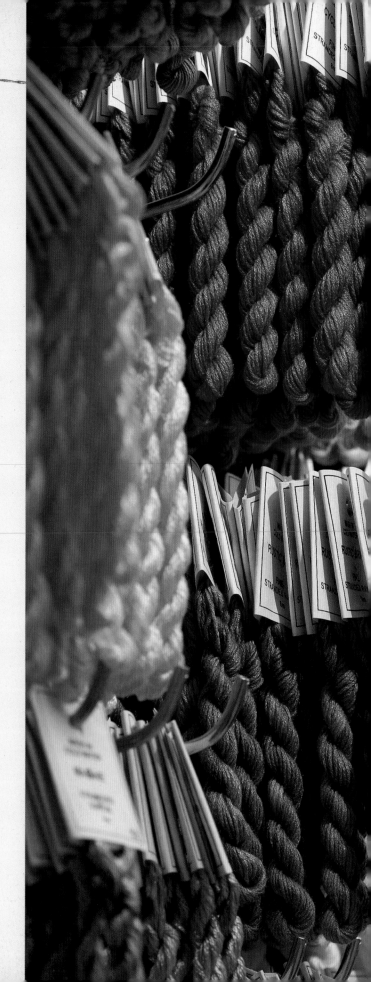

First published in Great Britain 2008
Search Press Limited
Wellwood, North Farm Road
Tunbridge Wells, Kent TN2 3DR

Originally published in South Africa in 2007 by
Metz Press, 1 Cameronians Ave
Welgemoed 7530

ISBN: 978-1-84448-340-2

Publisher	Wilsia Metz
Design and lay-out	Angie Hausner
Production assistant	Rowina Keiller
Photographer	Ivan Naudé
Line drawings	Klara-Marie den Heijer
Reproduction	Positive image

Printed and bound in China by Imago

Introduction

Embroidery has become such an important part of my life that it seems to take up most of my waking hours. I can truly say that I am addicted to embroidery. I have been stitching for the past 20 years and I still remember with fondness my first visits to the Cape Embroiderers' Guild. I could not wait to join the classes and learn more about all the new types of embroidery that I saw each month. I was fortunate to be taught by some world-class teachers and later to teach many wonderfully creative women from whom I have learned so much.

In 2001 I started dyeing and selling my own threads and Chameleon Threads very quickly became a business in its own right. Today we supply the South African market as well as shops in Australia, New Zealand, the United Kingdom and Europe. Using space-dyed threads has added an interesting dimension to my work, and I cannot imagine stitching without it. It's great to be able to just dye up a colour when you need it! In this book I have tried to pass on my knowledge of several types of embroidery as well as the many ways of using space-dyed threads.

Writing this book has been such a great privilege. It gave me a good excuse to sit and stitch without feeling guilty about having to dye threads. Doing so many projects has been a real challenge, as each type of embroidery has its own history, specific techniques, set of instructions and so on. I know that some of the projects look daunting and tricky, but I would urge you to try them. I graded the projects according to the level of proficiency required, ranging from * to ***, with * suitable for beginners and *** requiring a fair level of experience. I hope you will enjoy stitching these projects as much as I did, and that you will be inspired to create some beautiful heirlooms to enjoy for years to come.

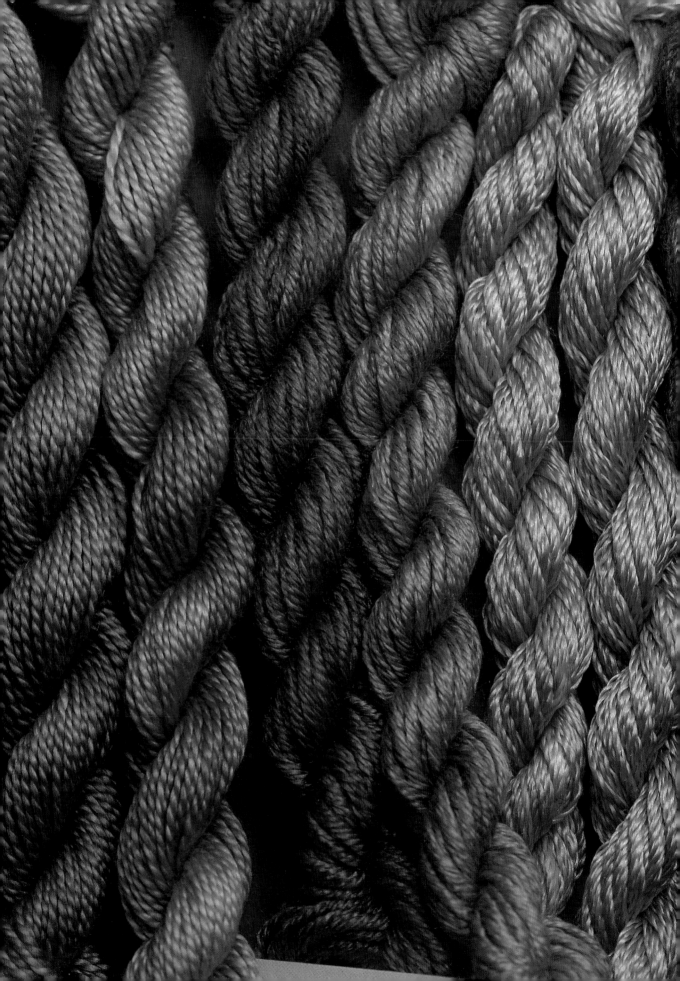

Space-dyed threads

Most embroiderers are familiar with the term variegated used for an embroidery thread. So how does a space-dyed thread differ from a variegated thread?

A variegated thread is usually a skein with definite and solid blocks of colour dyed on a bleached or natural base. This is not done by hand, but by machine; variegated threads are, therefore, mass produced. As one colour ends, the next starts, and colour blocks can be either hues of the same colour or different colours all together.

A space-dyed thread can be dyed either by hand or by machine, but the effect is more subtle than that of a variegated thread. This is achieved by the colours bleeding into each other, and where they meet a new colour is formed.

At Chameleon Threads all threads are dyed by hand as individual skeins, not in large tanks. This means that each skein is truly unique.

Buy enough thread for each project

All Chameleon Threads are hand-dyed individually. This means that there might even be differences from one thread to the other in the same dye lot, but it all adds to the charm of a unique product. It is not always possible to ensure the exact colour with each dye lot, but great care is taken to repeat the sequence of the colours. How a thread takes the colour is determined by many factors, for example the treatment of the raw threads at the spinning plant, humidity, chemical levels in our water and the quality of our dye (dye manufacturers also have variants in their dyes).

It is also important to note that different threads take the dye in different ways. Silk thread will dye up differently from cotton and so on. After the dyeing process all threads are washed several times in boiling water. We take care to ensure that all excess dye is washed out, but we cannot guarantee complete colourfastness. I do not know of anyone dyeing threads who can give this guarantee.

Some dyes are just naturally more unstable than others – the colour red comes to mind immediately. The way the

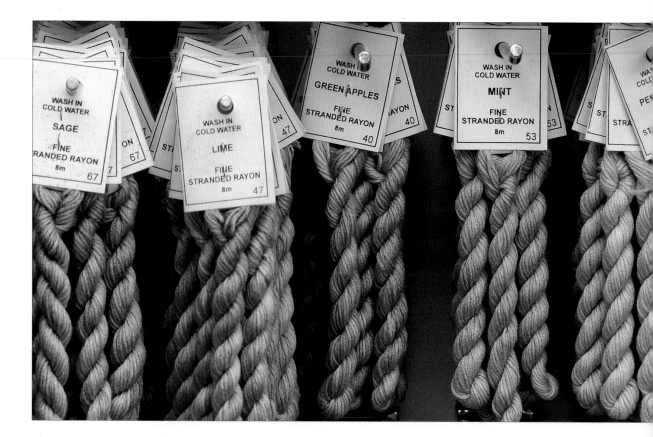

thread retains the colour may, therefore, differ from batch to batch, especially when the more unstable dyes are used.

For these reasons it is of the utmost importance that you buy enough thread of the same dye lot to complete a project. I cannot stress this enough. So often I have struggled to get a dye batch exactly the same as before when a customer has started on a large project and run out of thread. I do understand their predicament and want to be of assistance, but it is time consuming and costly.

Buy the best you can afford

Most companies who supply space-dyed threads dye their threads by hand. This automatically means that the process is much more labour intensive than threads dyed by machine.

Let me give you an idea what it all entails. Threads are wound into skeins, placed in dye baths and dyed using several colours on each skein. Next a fixative is added to ensure that dyes are fixed to the fibres of the thread. Then they are washed several times to ensure that all remaining dyes are rinsed out. The rinsed threads are hung out to dry. (Not so easy in winter!)

Once dry, each skein is wound into a twist, and tagged. At Chameleon this is all done by hand and by end of the process a skein of embroidery thread would have passed through five pairs of hands before it is ready to be sold. Threads like silk and rayon can be especially tricky as they are very delicate and great care needs to be taken not to damage them.

At Chameleon Threads we only use the best available unbleached base threads and this comes at a cost. As the dyeing process can be quite harsh (and my hands show the evidence of that) using an inferior thread is not an option. We all want our embroidered pieces to withstand the test of time. Imagine your piece being displayed a hundred years from now with threads still vibrant and intact. As you will be stitching many hours on your masterpiece, you owe it to yourself to buy the best quality you can afford.

Why use space-dyed threads?

Space dyed thread has truly opened up a whole new dimension of creativity for embroiderers. I don't think that space-dyed thread will ever replace single-colour embroidery

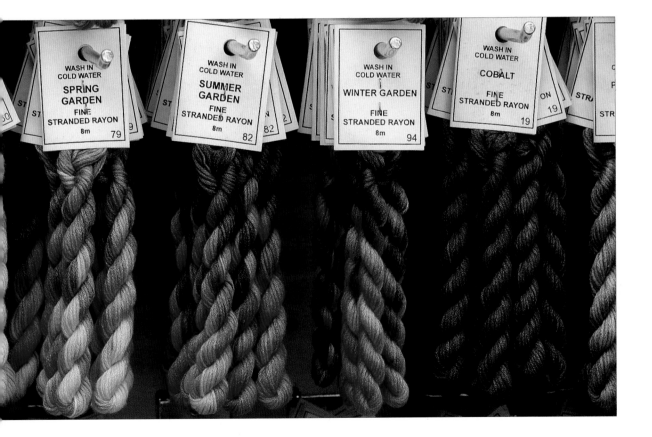

threads, however, as they are often used together. Space dyed threads do make life much easier for embroiderers because of the colour variation. Try using a skein of a space-dyed thread in a variety of colours of your choice to stitch a piece of canvas work using only one canvas stitch such as cushion stitch. You will be surprised at the wonderful result, as the thread will be doing the work for you, bringing subtle shadows, depth and colour variation. You will not be able to create the same effect with a single-colour thread.

This illustrates how using only one skein of space-dyed thread can produce a delightful piece of embroider

When stitching the alphabet or continuous border pattern on your next cross-stitch sampler, use a space-dyed thread instead of a single-colour thread. The effect is charming! When stitching a flower garden, try using Chameleon Threads Spring, Winter or Summer Garden. These threads have been designed especially so that you do not have to change to a new colour every time you move on to the next flower.

Different threads, different uses

Like ordinary embroidery threads, there are various types of space-dyed threads with different uses.

STRANDED THREAD

Stranded thread is by far the most popular type of embroidery thread used. It is a versatile thread as it can be divided into six separate strands. It is suitable for most forms of embroidery, for example cross-stitch, canvas work, goldwork, blackwork and so on.

Of all the stranded threads **stranded cotton** is probably the most utilized. It is made of 100% long-staple cotton and can be used in almost every type of embroidery. It is also double-mercerised to give it a beautiful lustre.

If you are looking for a shiny, smooth and vibrant thread to work with, **stranded rayon** is the one. It can be difficult to work with as it tends to slip and can tangle easily.

Fine rayon is a new and exciting multipurpose six-stranded thread that has the lustre of rayon and the thickness of stranded cotton. This thread is very versatile as it can be divided into strands, like stranded cotton.

The ultimate in stitching luxury for me is using **pure silk**. I dye up two types of silk thread. The *Au ver a Soie de Paris* is spun directly from the cocoon silk fibres and is a beautiful lustrous thread. It has a wonderful shine and gloss and is perfect for delicate work. The *Au ver a Soie d'Alger* is spun from the worsted silk and has a matt finish, but still has a wonderful sheen.

PERLÉ COTTON

Perlé cotton is a highly mercerised, twisted and lustrous 100% cotton thread that can't be divided. It is very popular as it is affordable, very versatile and comes in a wide colour range. It is used in many forms of embroidery, for example canvas work, freestyle and many counted-thread embroidery styles. Thickness varies and the thread is available in no's 3, 5, 8 and 12 with no's 8 and 12 proving the most popular. This thread gives a wonderful texture to your work.

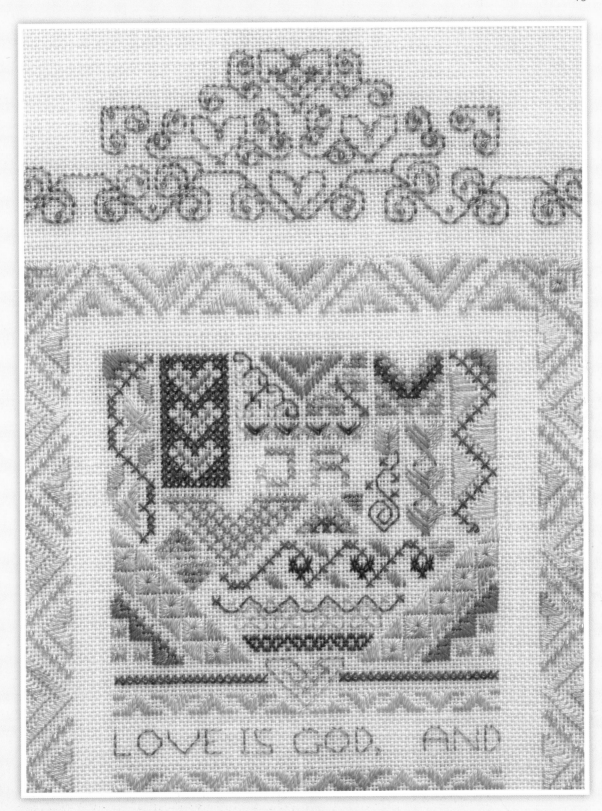

Sampler stitched by John le Roux. He used Marigold Pure Silk for the border and Lavender Pure Silk for the decorative scroll at the top.

RIBBON

There is a wide range of embroidery ribbons in a vast range of colours available on the market. We have used Di van Niekerk's Hand Painted range in this book. Hand-painted ribbon is the most suitable for creative embroidery as the varying colours and changing shades help create the same subtle effect and depth achieved by using space-dyed threads. The silk ribbon comes in widths of 2mm, 4mm, 7mm.

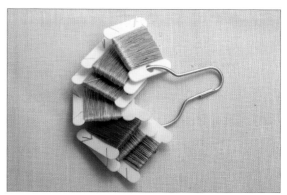

A very useful way to store your threads for one project

Caring for your embroidery threads

I often have students bring their floss boxes to class with a mass of tangled threads, and watching them trying to extract a specific colour from it, is rather distressing. Threads need to be properly cared for to enjoy their prolonged use.

STORING

You can store threads in various ways, but I prefer unwinding my threads onto floss cards, and storing them in proper floss boxes when not in use. If you do this, write the name of the thread on the floss card. Working from unmarked floss cards it is easy to make mistakes at night or when the light is not good enough for you to tell colours apart that are close together. Believe me, it is no fun unpicking everything when you realize

that you've been using the wrong colour. I have found that using a simple shower-curtain hook to keep all my threads together works brilliantly. You can unwind the threads onto floss cards and slip the floss cards onto the shower-curtain hook. For a small project, put all your threads onto one hook, and for larger projects you can put threads of similar colours together. You may think I'm stating the obvious, but keep your threads away from direct sunlight. Even bright daylight can fade threads. I have bought threads that had faded slightly while hanging in the shop. The fading may seem negligible when you look at the skein of thread, but quite noticeable when the thread is stitched into a project.

Caring for the embroidery

As I have mentioned before, it is impossible to guarantee the colourfastness of hand-dyed threads. It is, therefore, very important that great care should be taken when washing a piece of embroidery that has been stitched with a hand-dyed thread. Most washing powders contain a bleaching component. While great for getting your whites whiter than white, it is a no-no for using on your embroidery. Wash your work in cold water with a very gentle soap suitable for wools and delicates. Gently squeeze out excess water (do not wring) and roll up in a clean towel. Dry flat, away from direct sunlight. Place upside down on a padded towel. If necessary, iron gently with a dry iron, and **never use steam**.

If you have stitched a piece that will be framed, always remember to hang your picture in a spot that does not get direct sunlight.

Space-dyed threads for different effects

Most embroiderers do not realize that they can use the space-dyed threads for different effects. You can manipulate the col-

our in the threads to suit your design by varying the way you cut and stitch the threads, and also by varying the way you divide and combine the threads.

CUTTING THE THREAD

When undoing your skein of thread, first take the time to look at how the thread was dyed before winding it onto your card. You might feel that you want less visibility of one colour, say for example green. Simply cut the thread in the green section as this will mean that this colour will be worked away when starting and finishing.

STITCHING WITH THE THREADS

I used Winter Garden, a thread where the colours are well represented, to illustrate different ways of manipulating the thread.

SHADING EFFECT

For this stiched sampler I stitched a small piece in long-armed cross-stitch. Cut a length of thread and divide it into 3 lengths of 2 strands each. Lay them down in front of you all facing the same way.

Now thread your needle with the first length from the left and take note of how much thread is used for the away knot. Repeat the next row in exactly the same way.

Shaded effect

RANDOM EFFECT

For this sampler I stitched a small piece in two-sided cross-stitch. Using 2 strands of stranded cotton, first stitch the bottom legs of the crosses and then the top legs. The effect is charming as most crosses will be two-tone.

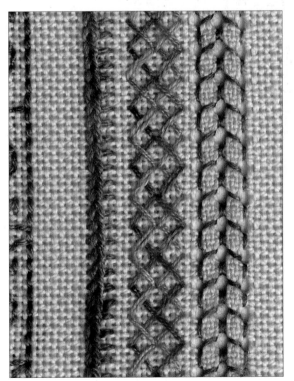

Random effect (cross stitch section in the centre)

CONTINUOUS EFFECT

For this illustration I stitched a small piece in Montenegrin stitch. Cut a length of stranded cotton and divide into 3 lengths of 2 strands each. Lay them down in front of you all facing the same way. Thread the needle from the left and start by stitching from left to right. Thread the needle from the right when using the next thread, and lastly use the remaining thread. This will insure a continuous colour sequence.

MOTTLED, SHADED EFFECT

For this illustration I stitched a small piece in two-sided Italian cross-stitch. Cut a length of stranded cotton and divide into 3 lengths of 2 strands each. Now separate each length of threads (2 strands) and rejoin them head to tail.

Stitch the rows in exactly the same way as for the shaded effect. The subdued effect here is delightful and will work particularly well in samplers.

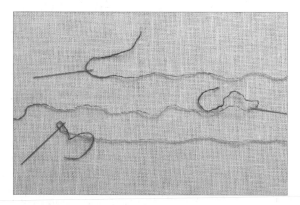

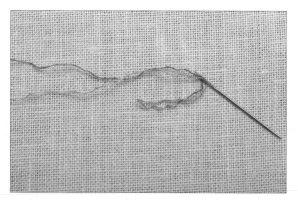

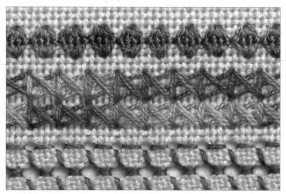

Continuous effect (Montenegrin stitch in the centre)

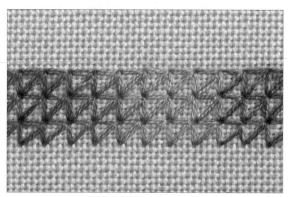

Mottled shaded effect

Stormy seas, Granite and Winter-garden used in the sampler

Different thread colours in one design

Embroiderers often find it difficult to bring together several matching space-dyed threads in one project. Here are a few guidelines:

✳ Remember that it is deceptive to match colours using full skeins. As you will often only be using 2 strands of thread per colour, once stitched, the intensity of the colours will appear much lighter.

✳ Consider how much of the colour is used in the design. Even if the colour is not an exact match it can be used in small amounts. In my sampler *Flowers, Acorns and What Not's*, I used Granite pure silk for the acorns and buds. I

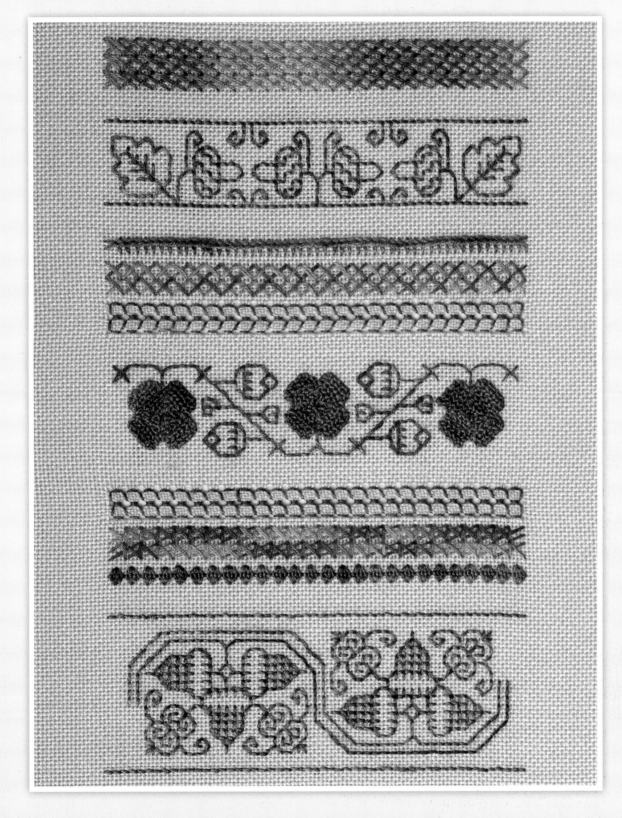

In this sampler the colours Stormy Seas, Granite and Winter Garden work very well, although the skeins may appear not to match at all.

then used Stormy Seas 6-stranded fine rayon for the stems. When the skeins are placed side by side, these two colours are not an exact match, but as only a small amount of Stormy Seas is used, it blends in beautifully with the Granite.

✳ Choose your favourite multi-coloured thread. Pick out the colours in this thread and use these as a guideline to add other colours that are similar.

✳ If you feel really unsure about choosing colours, use a piece of fabric that you really like as a guide. Textile designers are well trained to combine colours.

✳ It is a good idea to get a good book on colour use and the colour wheel to help you to put together different colours.

Here I chose Blushing Bride and added Marine, Daffodil and Rose to complement it. You should use the three additional colours in the same proportion as they appear in Blushing Bride thread.

Getting started

You should now have a good understanding of space-dyed threads and their uses. These threads are the common denominator in this book. As the projects are all based on different types of embroidery, the other materials used may vary according to the specific embroidery type.

Fabric

As this book will be covering several types of embroidery, let's look at fabric suitable for each type of embroidery.

COUNTED-THREAD PROJECTS

Even-weave fabric is used in all counted-thread projects. This would include cross-stitch, Casalguidi, hardanger, blackwork, wessex embroidery and so on.

An even-weave fabric is defined as fabric with the same number of threads running vertically as horizontally. These threads can be singular (as in linens), in pairs (as in hardanger fabric) or in blocks (as in Aida).

Even-weave fabric will always be identified with a certain thread count. This will indicate how many threads are found in one square inch (or 2,5 cm).

The higher the count, the finer the fabric.

Linen
Linen is by far my most favourite type of fabric for counted-thread work. It comes in various colours and thread counts.

TIP: As linen is very expensive, never store your fabric in plastic or near direct sunlight. Store it rolled rather than folded as fold lines may be difficult to remove.

Hardanger fabric
The weave of this 22-count fabric is made up of pairs of threads. Although this fabric was originally designed especially for hardanger work, I prefer to do hardanger on finer linen.

Aida
This fabric is distinguished by sets of threads used for the warp and weft in the weaving process. Where the threads overlap a solid block is formed. These are the blocks over which cross-stitches are worked. Aida is good for those strug-

gling to see finer threads. While this fabric works well for cross-stitch, half and quarter cross-stitches are difficult to stitch through the fabric block.

Even-weave fabric comes in many colours and counts

Use space-dyed fabric with space-dyed thread for a charming effect

CANVAS WORK

Canvas work is done on canvas, classified as an open even-weave fabric that has been stiffened with sizing. There are two main types of canvas. **Penelope canvas** is woven with pairs of threads and is quite strong. It is mainly used for items that will be subjected to heavy wear such as rugs and uphol-stered furniture. A 10-count is the most widely used as this will take thick wool without a problem.

Interlock mono canvas is woven with single threads as well as pairs. The weft is a single thread, but the warp is composed of a pair of threads that is wrapped around the weft in the weaving process. Mono canvas comes in many thread counts from 10 to 22. I prefer an 18-count as this works well for small designs and stranded cottons. Perlé no 8 gives good coverage on 18-count canvas.

TIP: Always store canvas flat or rolled and never fold it.

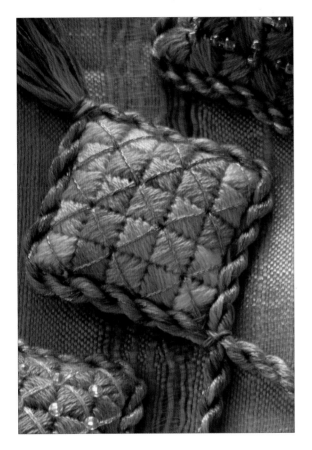

COTTON AND SILK FOR FREESTYLE AND GOLDWORK

For freestyle embroidery and goldwork, choose a good quality cotton or silk with a tight weave. If the fabric is too lightweight you can always add a good quality backing fabric. I love the feel of pure silk and enjoy stitching on this rich fabric.

When choosing your background fabric you must consider if the project will be washed after stitching. If so, all fabric needs to be pre-shrunk.

There has been a tendency to simply use calico for any project that requires a crème-coloured background. As a result I have seen some beautiful stitching done on very poor quality calico. Do not be tempted to buy a cheap fabric and then spend hours of work on what will inevitably be an inferior product. If fabric is really very cheap – stay away!

HOW MUCH FABRIC?

Embroidery fabric for counted work can be very expensive, so use this method to calculate exactly how much you need. Count the blocks on the diagram of your design vertically and horizontally. Let's say it is 100 x 150 blocks and you will be working on 22-count fabric (22 threads per inch or 2,5cm). You will be stitching over 2 threads.

22 threads ÷ 2 = 11 stitches = 11 blocks on your diagram:

100 ÷ 11 = 9	150 ÷ 11 = 13
9 x 2,5 cm = 22,5cm	13 x 2,5 cm = 32,5
22,5 cm + 10 cm (for edge)	32,5 cm + 10 cm (for edge)
= 32,5 cm	= 42,5 cm
33 cm (rounded off)	43 cm (rounded off)

For this project you will need 33 x 43cm of fabric.

Needles

Using the right needle for your project is of the utmost importance. This may sound very basic, but I have often seen embroiderers trying to do canvas work or counted-thread work with a crewel needle.

Choosing the correct needle can be tricky as there is such a vast variety. Whichever needle you use, remember that the bigger the number, the smaller the needle.

Needles come in the following categories:

✳ *Crewel* needles are the shortest needles used for embroidery and come in sizes 1 to 10.

✳ *Chenille* needles are sharp pointed, have large eyes and are easy to thread. They come in sizes 13 to 26.

✳ *Tapestry* needles are blunt pointed, have large eyes and come in sizes 13 to 28. They are used in counted-thread work as well as canvas work as the fabric does not have to be pierced.

✳ *Straw* needles are long with a small eye. The thickness of the needle is the same in its entire length. Straw needles are very useful for bullion knots as the small eye means that the threads can slip off very easily.

Scissors

I must admit that I cannot resist a pair of embroidery scissors. I have a wide variety that I have bought over the years, from beautifully decorated ones to others that are just plain and functional. When choosing a pair of embroidery scissors, make sure that you choose one that is fine pointed and very sharp. This is very important when, for example, cutting threads in hardanger work. Never cut paper with your embroidery scissors as this will definitely blunt them. If necessary, hide them from your family!

Embroidery scissors should be very sharp

TIP: When doing goldwork make sure that you have a separate pair of scissors for cutting the metal threads, as this will blunt your scissors.

Frames and hoops

I use a frame for all embroidery. Stitching tends to distort most fabrics and most types of canvas and I find that working with frames and hoops keeps my work neat and taut.

Hoops are mainly used for counted and freestyle embroidery. You could use a small hoop just taking the piece of work you are busy with, but this may distort work already done. The safest is to use a hoop big enough to take the whole design. With linens hoops tend to distort the fabric and you may end up with a mark that cannot be removed. Remove the hoop when you are not stitching, even if you think that you will come back to it soon. Never use a hoop on canvas work as it will distort the fabric.

Some embroiderers prefer using a *scroll frame*. This consists of a pair of round scroll bars attached to a pair of side bars. Each round scroll bar has a piece of webbing attached to it onto which you sew the top and bottom of you canvas or fabric. Once the fabric or canvas is wound up in opposite directions the sides are laced up to the side bars. I personally do not like this type of framing, as moving your work becomes a laborious task.

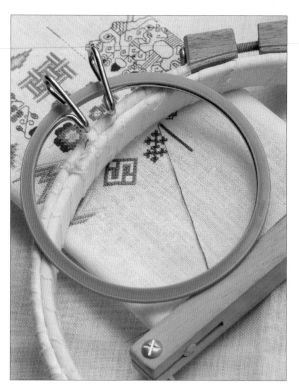

Hoops and a scroll frame

Stretcher bars are easy to use and inexpensive. They consist of four wood strips that are dovetailed to fit into one another to form a square or a rectangle. They are sold in pairs and can mix and match to take all sizes of embroidery. When buying a stretcher bar, just make sure that the wood is soft enough to take a thumbtack easily.

When stitching a canvas-work design, I have a *cardboard frame* cut for my work. The stiff cardboard used for picture framing works well and my framer cuts them for me at a minimal cost. The canvas is then simply taped to the frame with masking tape. This obviously only works when the designs are small. Some shops sell a set of these frames cut from a light-weight wood.

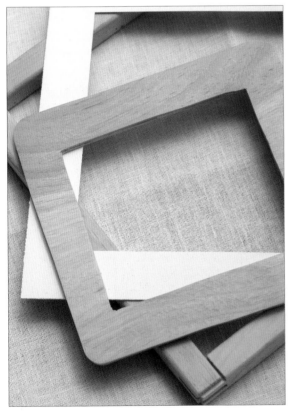

Stretcher bars, wooden frame, cardboard frame

other tools

Good light: It is very important to stitch with good lighting. I bought myself a light that can be lowered over my shoulder when I am sitting down and it is very effective. You could also choose a lamp that has a magnifier built in.

Magnifiers: I have often seen embroiderers struggling because they have problems seeing what they are stitching. I now have several pairs of reading glasses and I just cannot stitch without them. You can get magnifiers that rest on your chest, but they are a bit clumsy. If you wear spectacles you can get magnifiers that clip onto your spectacles.

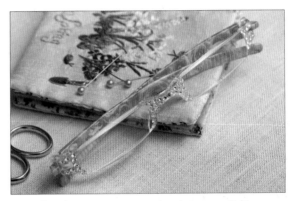

Use reading glasses to ensure you can see what you are stitching

General stitching tips

✳ When stitching never cut your thread too long. I would say about 30-40cm is the ideal length. If your thread is too long, it will show wear and tear as it is taken through the fabric several times. (If this happens when you are using shorter lengths, the thread is of an inferior quality.)

✳ Similarly, when you unpick thread, it will also get damaged. Do not be tempted to re-use thread that has been unpicked. Rather end off and start with a new piece.

✳ Some threads, especially silk and rayon, tend to twist and often knot at the back while you are stitching. If this happens, simply hold up your work and let the needle hang free while allowing the thread to unwind itself. Do not get impatient and pull at the thread. You can even run your thumb and forefinger along the thread to unwind it. You might find that you need to do this several times.

✳ To prevent your silk and rayon threads from "jumping", wet the thread slightly before stitching. Do not be tempted to do this by licking the thread. Tests have identified the yellow marks found on old pieces of embroidery as saliva marks. This happened as the embroiderer licked the thread before threading the needle. Rather keep a damp sponge

next to your work for this purpose. An alternative for silk threads is to run them through beeswax very lightly.

Beginnings and endings

When beginning your stitching never use a knot at the back as this will show on the front; rather use an **away knot**. With this method you "park" your knot on the front of your work some distance away from where you start. Do not park it outside the design but in your stitch path. Once the tail has been stitched in you simply cut away the knot on top of the fabric.

Starting with an away knot, park your knot some distance away from where you start. Once the tail is stitched in, the knot is cut away.

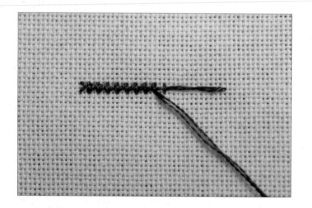

When stitching a design in long and short stitch, you can start by making a small backstitch. Cover this up with your stitching.

How you end off is very important and needs to be thought through. The following points are worth thinking about:

✳ Try to end off in the colour that you have just stitched and not in the adjacent one. When you have to unpick a colour your work won't start to unravel.

✳ End your threads in different directions to minimize the thickness at the back.

✳ End off in the same direction as your stitching and begin your new thread from the direction the previous one came from.

Care while you are working

You will be surprised how easily work gets dirty while stitching. Always wash your hands before you start even if you think they are clean. I keep my projects wrapped in a towel when I am not stitching.

✳ Be careful when applying hand cream before you start stitching. Ensure that it has been absorbed completely or you may stain your work.

✳ Always take your work off the frame and store rolled up.

✳ Never leave a needle in your work. You never know when you will get back to your stitching and needles can leave unsightly rust marks that are impossible to remove.

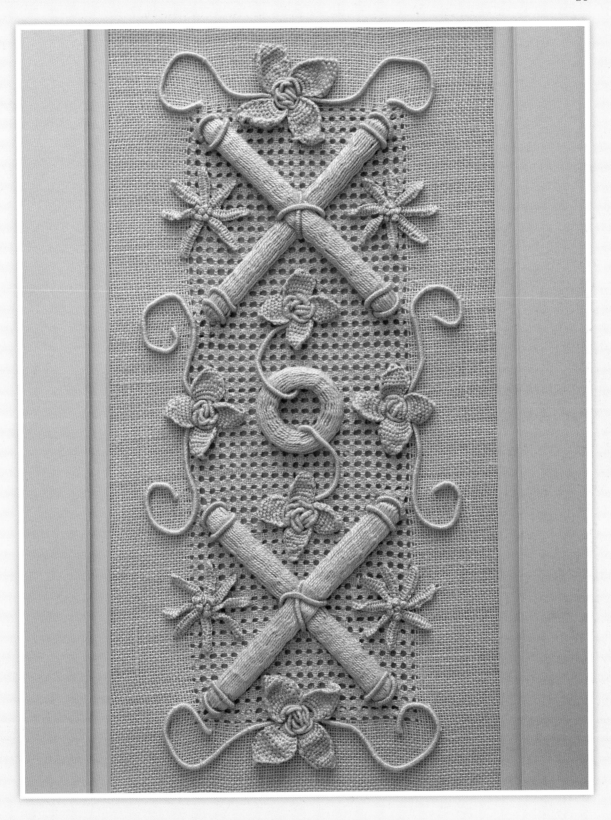

I designed this piece and embroidered it on 32 count fabric in a subtly shaded thread I dyed myself.

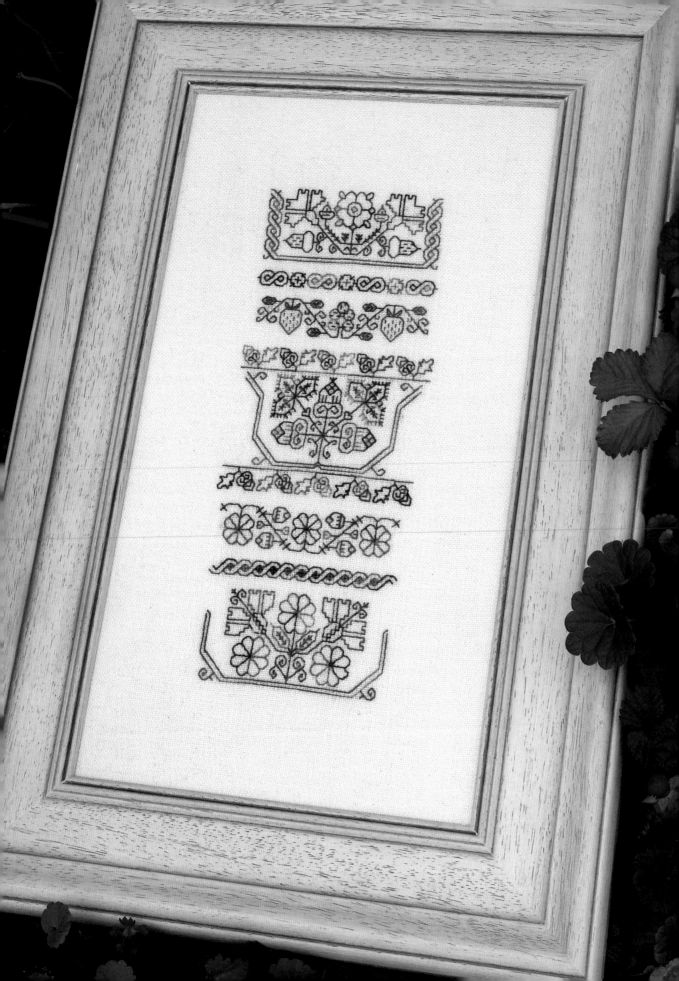

Blackwork

Blackwork is a form of counted-thread embroidery worked in black silk on a white linen background. First called Spanish work, as it was passed from Spain to Western Europe and England, it later became known as blackwork. It is believed that Catherine of Aragon introduced blackwork to England when she left Spain to marry Arthur, the son of Henry VII. When Arthur died she married his brother Henry and became Queen of England in 1504. She was a skilled needlewoman and could certainly be credited for developing the technique in England.

The individual design elements in this sampler were copied from Historical Designs for Embroidery.

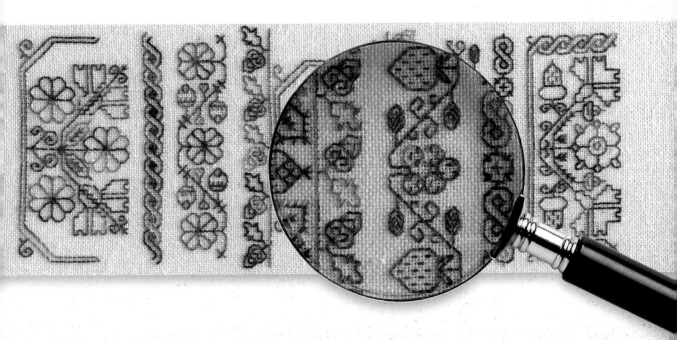

Basic blackwork technique

As blackwork was mostly used on cuffs and collars, it needed a stitch that looked the same on the back as on the front. For this needlecrafters used Spanish stitch, or, as we know it, double-running or Holbein stitch. The stitch was named after Hans Holbein, a Dutch artist who frequently painted his subjects wearing garments decorated with blackwork. Back stitch was also used, but mostly for outline work and where only one side of the work showed.

DOUBLE-RUNNING OR HOLBEIN STITCH

This stitch is not as easy as it sounds. When stitching in a straight line it is no problem, but it can be tricky planning your stitch pattern for an intricate design. The idea is that you stitch one row of running stitches and on your return fill in the gaps (see page 117).

When stitching an acorn, for example, it would mean that you would first stitch half of the acorn bottom, then continue with the top and then complete the bottom.

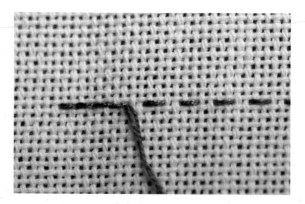

This sample shows the first row of stitches as well as the return journey.

To stitch this design, start between the top two leaves. First go down the centre working every alternate stitch and then return. Next, stitch the top part of the leaf, every alternate stitch only. Continue until all leaves are stitched and then complete the top part of the leaves.

Doing blackwork with space-dyed thread becomes even more fun. If you are stitching with a solid colour, you will not see a difference coming back for your second row of running stitch. If you are stitching with a thread that has huge colour variants, the stitches in the second row of running stitch will differ greatly from the first and form an interesting contrast. Note the interesting effect (below) when the space-dyed thread has significant colour variants

BACKSTITCH

If you find double-running or Holbein stitch too challenging, you could stitch your entire sampler using backstitch (see page 114). However, you would not get the interesting contrast as described and illustrated above.

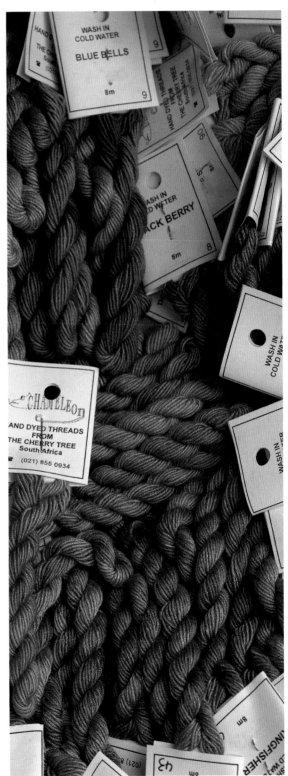

COLOUR VARIATION

If you do not like the idea of stitching this design in a multi-coloured thread, try using Chameleon stranded cotton or fine rayon in Slate or Charcoal. Adding some gold thread will give this design a more traditional feel.

READING THE DIAGRAM

When reading the diagram, note that each block represents **two** fabric threads. This differs from other counted-thread projects in this book where each line on the grid represents one fabric thread.

PREPARING THE FABRIC

Iron the fabric and finish the raw edges to stop them from fraying. Fold the fabric in half horizontally and vertically and tack a line of running stitches both ways.

STITCHING GUIDE

Use two strands of thread throughout and leave eight fabric threads between rows. Start your work in the centre of row 4 where all five stems meet, indicated on the diagram by the arrows. Stitch from the centre outwards towards the top and the bottom. Note: to centre the design, the design in row 3 must be moved one fabric thread to the right.

COLOURS AND ROWS

Row 1
Stems and curlicues – Green Olives
Flowers and acorns – Winter Garden
Border – Amber

Row 2
Amber

Row 3
Stems and leaves – Green Olives
Flower – Winter Garden
Strawberries – Amber

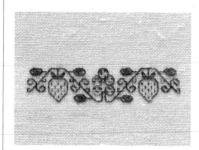

Row 4
Stems and curlicues – Green Olives
Leaves and acorns (large and small) – Winter Garden
Border – Amber

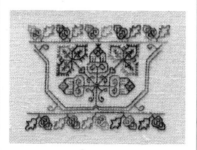

Row 5
Stems – Green Olives
Flowers and buds – Winter Garden

Row 6
Winter Garden

Row 7
Stems and curlicues – Green Olives
Flowers – Winter Garden
Border – Amber

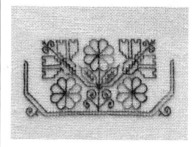

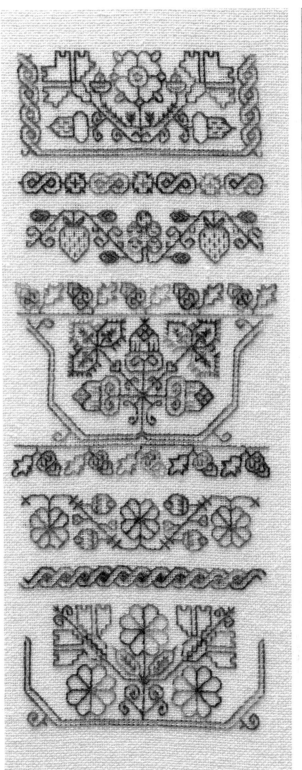

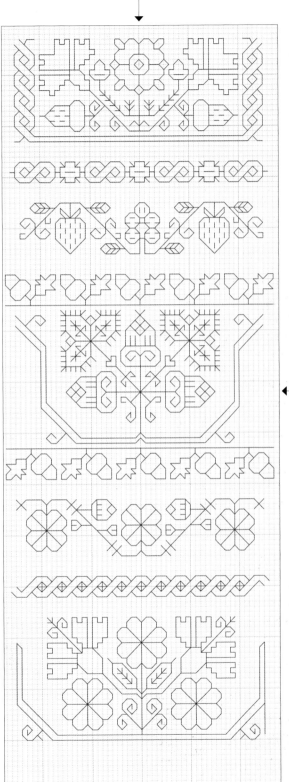

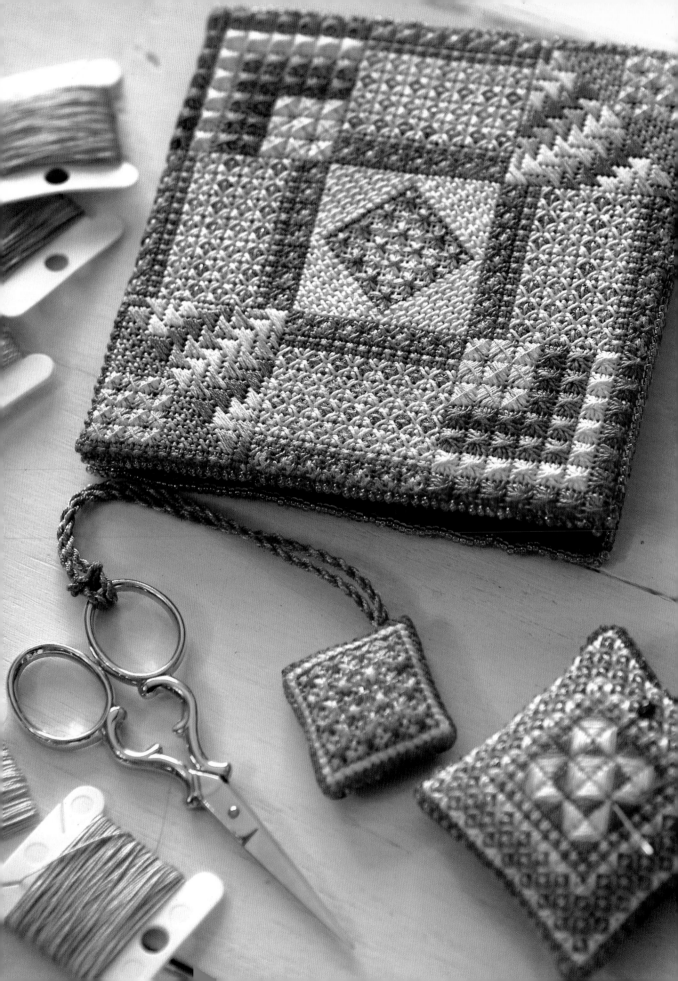

Canvas-work

When people talk about canvas-work the terms *needlepoint* and *tapestry* are often used. This can be confusing but is easily explained. A *tapestry* is a large textile piece depicting pictures and is hand-woven on a loom. There are known samples from ancient Greek times, but the most productive time for tapestry weaving was during the 14th and 15th centuries. Magnificent pieces were woven in Germany, and later in France, Belgium and Holland. Attempts to reproduce the look of the woven tapestries with tent stitch on canvas followed. *Needlepoint* is defined as counted stitches worked on woven canvas completely covering the canvas. During the 15th and 16th centuries needlepoint was mainly done in tent stitch and many of these pieces are still seen in museums today. My favourite pieces are those embroidered by Mary Queen of Scots while under house arrest in Hardwick Hall in England. By the 18th century shops were selling hand-painted canvases and wool for needlepoint. As special artists had to be employed to design and paint these, the canvases were expensive.

Today we are rediscovering needlepoint using various threads, ribbons and beads, adding a whole new dimension to our stitching. Canvas is often painted and treated in various ways to make it more interesting so needn't be completely covered in stitches. Stitches are also not limited to tent stitch, as we have over 300 stitches to experiment with.

Keepsakes

Level of proficiency

✹ ✹

YOU WILL NEED

18 count canvas
> *Needle case: 20 x 20cm*
> *Pincushion: 10 x 10cm*
> *Scissor keep: 6 x 6cm*

Stranded Cotton
> *Chameleon Grape*
> *Chameleon Seashells*
> *Chameleon Fern*

Perlé no 8
> *Chameleon Grape*
> *Chameleon Seashells*
> *Chameleon Fern*

> *Kreinik Metallic fine (#8) braid no 093*
> *Tapestry needle no 26*
> *Wide masking tape*
> *Stretcher or cardboard frames to fit size of canvas or work all three designs on one large piece of canvas in a large frame*

To make up
> *2 pieces of cardboard 11,5x11,5cm*
> *Double-sided tape*
> *Matching backing fabric*
> *2 pieces of felt 11x11 cm*
> *Matching #11 mauve beads*
> *Small piece of stuffing*

TIP: I usually make a mark at the top of the frame to remind me to hold my frame the right way up. Without such a mark you may have difficulty keeping your stitch direction the same all the time.

Colour variation

Chameleon Golden
Green (Grape)
Chameleon Sea Sand
(Sea Shells)
Chameleon Amber
(Fern)
Madeira Metallic Gold
no 34 (Kreinik Metallic
fine (#8) braid no 093

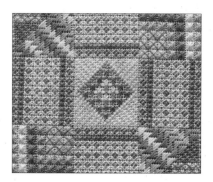

Needle case

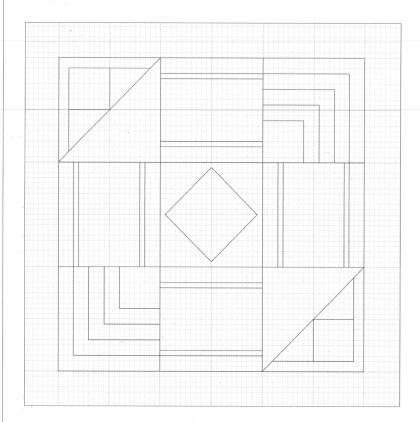

Tape the canvas to the cardboard frame using wide masking tape or pin it to the stretcher frame and find the centre of your canvas.

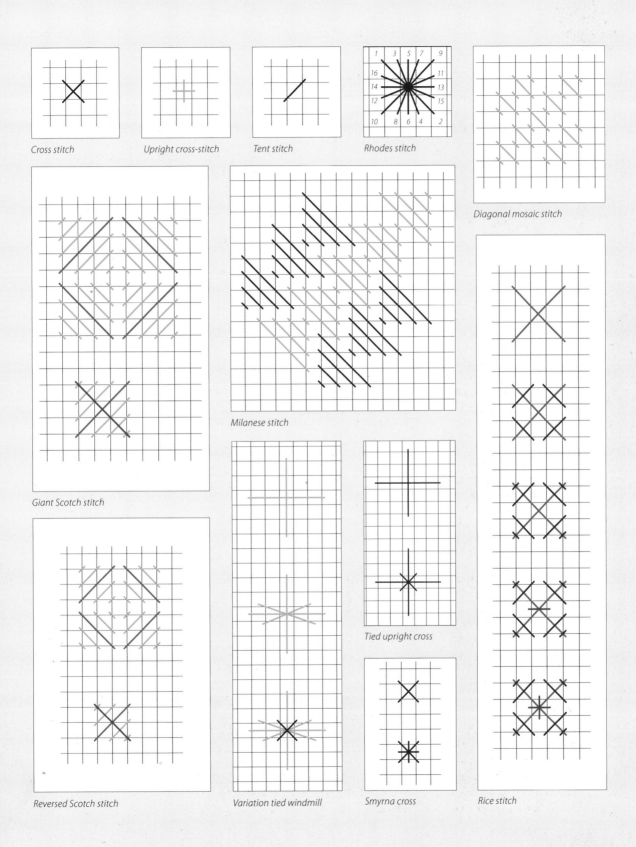

Cross stitch

Upright cross-stitch

Tent stitch

Rhodes stitch

1		3	5	7		9
16						11
14						13
12						15
10		8	6	4		2

Diagonal mosaic stitch

Giant Scotch stitch

Milanese stitch

Reversed Scotch stitch

Variation tied windmill

Tied upright cross

Smyrna cross

Rice stitch

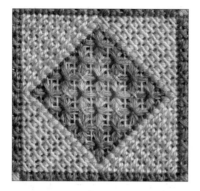

1. Work **section 1**, the centre block. Make 4 tied-windmill stitches in 4 strands of Seashells stranded cotton in centre, with remaining surround in 4 strands of Fern. Ensure that all the stitches are in the same direction and tie them with Grape perlé no 8. Using Kreinik braid, stitch crosses to tie large stitches together.

2. Work a surround of upright cross-stitch using 4 strands of Seashells. Add a row of tent stitch between windmill and upright cross-stitch using Grape perlé no 8.

3. Fill the four corner-triangles in diagonal mosaic-stitch using Seashells perlé no 8.

4. Start **section 2** by stitching the first row of rice stitches in 4 strands of Fern and crossing the legs with Grape perlé no 8. The middle sections of these stitches are tied with a small upright cross-stitch in Kreinik braid.

Section 1 (above) Section 2 (below) Section 3 (opposite page)

5. Stitch a row of Smyrna crosses using Fern perlé no 8.

6. Work 4 rows of rice stitch alternately using 4 strands of Fern and 4 strands of Grape for the large crosses. Cross all 4 rows with Seashells perlé no 8. The middle sections of these stitches are tied down with a horizontal stitch in Kreinik braid. (*See* rice-stitch diagram, step 4, page 35.)

7. To complete section 2 repeat step 5, then step 4. Repeat steps 4-7 on the other 3 sides of the centre block.

8. Work **section 3** (right) in Milanese-stitch triangles using 4 strands of Sea-shells, then 4 strands of Fern, followed by 4 strands of Grape in sequence.

9. Complete the outside corner in reversed scotch-stitch. First make the large centre stitches in Fern perlé no 8

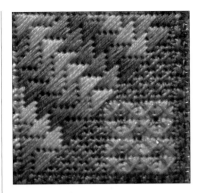

and then fill in the smaller stitches using 4 strands of Seashells. Cross the small blocks with Kreinik braid. (See reversed scotch-stitch diagram step 2 on page 35.)

10. Fill in the small triangles in diagonal mosaic-stitch using Fern perlé no 8.

11. Add a row of Smyrna stitch in Grape perlé no 8 Grape and repeat section 3 on the opposite side of the centre block.

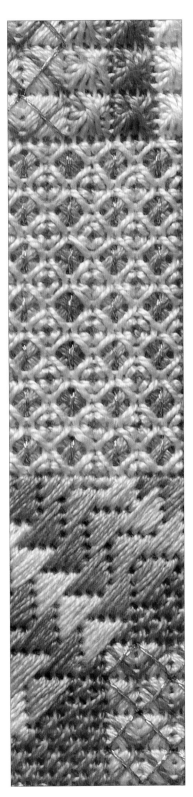

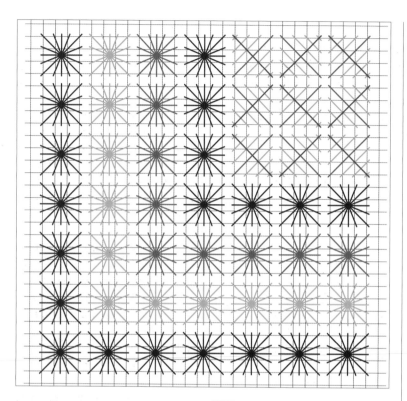

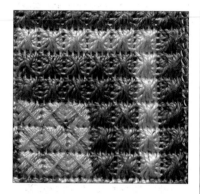

12. Start **section 4** by working a giant scotch square using Fern perlé no 8 and 4 strands of Seashells. Cross the large blocks with Kreinik braid. (See diagram of giant scotch stitch step 2 on page 35.)

13. Work four rows of Rhodes stitch to form the corner using Grape perlé no 8, then Fern, then Seashells and again Grape perlé no 8.

TIP: Ensure that the threads in the Rhodes stitches all follow the same direction or they will look very untidy.

MAKE THE NEEDLE CASE

Cut 2 pieces of cardboard 11,5x11,5 cm; stick some double-sided tape on one followed by the embroidered canvas. Pull your work tightly around the cardboard and ensure that no white canvas shows at the front.

Trim the remaining edge to about 1,5 cm, neatly fold it to the back of the cardboard and stick it down with double-sided tape. You can trim away some canvas on the corners before mitring them, but be careful not to take away too much. Close the mitred corners by stitching them together.

Cut and stitch a casing of 2,5x 10cm from the backing fabric. Turn inside out and iron neatly. Cut this in half to form the two

hinges along the spine of the needle case. Position the two hinges on the cardboard about 1,5cm away from the top and bottom edges leaving about 3cm to protrude. When you are sure of their position, secure them with double-sided tape. Position one 11x11cm piece of felt on top to serve as padding on the inside of the needle case to hold the needles.

Next cut a 12,5cm square of backing fabric. Fold in the seam allowance, place over the felt padding and pin in position. First close up the spine side with small overcast stitch in a matching thread. Using a beading needle, next close up the other three sides but add a no 11 mauve bead with every stitch.

Repeat to make the back cover of the needle case. You can either embroider a matching canvas-work back or just pad the cardboard with felt and cover it with any matching fabric.

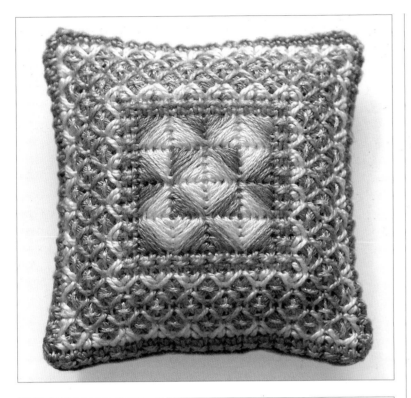

Pincushion

You will use the same stitches as for the needle case. Arranging them differently creates a completely different design. Note how the double row of rice stitches worked around the centre block forms a unit if you cross the outside legs in Seashells perlé no 8 and the centre legs in Fern perlé no 8. Prepare the canvas as you did for the needle case. *Note how using two colours when crossing the rice-stitch legs adds interest to the edge.*

1. Work the large centre stitches in the cushion-stitch blocks in 4 strands of Fern stranded cotton. This gives you a grid to work on. Add the other stitches in 4 strands each of Seashells and Grape.

2. Work a row of Smyrna stitch around the centre block using Fern perlé no 8.

3. Work 2 rows of rice stitch step 1 only, using 4 strands of Grape stranded cotton. Now cross just the outside legs of the 2 rows using Seashells perlé no 8. (See rice-stitch diagram step 3 on page 35.) Next cross the inside legs with Fern perlé no 8, but only complete step 2 as shown in the rice-stitch diagram (see page 35).

4. Add the small upright crosses in Kreinik Metallic braid and the straight stitches crossing the big crosses as shown in the rice-stitch diagram step 4 (see page 35).

5. Complete the design with a row of Smyrna stitches using Grape perlé no 8.

MAKE THE PINCUSHION

Cut a piece of matching fabric for the pincushion and stitch to the back of the embroidered piece leaving an opening for stuffing. Stuff and close up the opening.

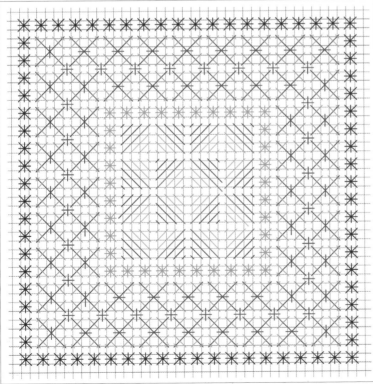

Scissor keep

Have you ever lost your scissors while stitching in a group or guild? I know how infuriating it can be to get home to find that some one has accidentally packed your favourite pair of embroidery scissors. If you personalize them with an embroidered scissor keep, no one will take them by mistake.

For this small scissor keep I used the centre design from the needle case and added an extra border of upright cross stitches.

1. Stitch the 4 centre crosses in tied cross-stitch using 4 strands of Grape stranded cotton. Cross with 4 strands of Fern stranded cotton. Complete the rest of the crosses first using 4 strands of Fern and then crossing with 4 strands of Grape. Now fill in the very small and larger crosses using the Kreinik metallic braid.

2. Using 4 strands of Seashells stranded cotton work a surround in upright cross-stitch.

3. Now add a row of tent stitch using Grape perlé no 8 between the tied cross-stitches and the upright cross-stitch surround.

4. Finish with another row of upright cross-stitch using 4 strands of Grape stranded cotton.

MAKE THE SCISSOR KEEP

Complete in the same way as the pincushion, but add a twisted cord of Grape perlé no 8 in one corner before closing up.

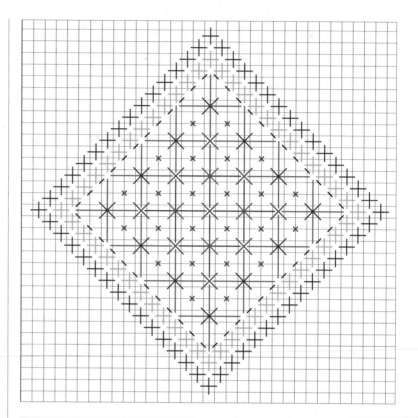

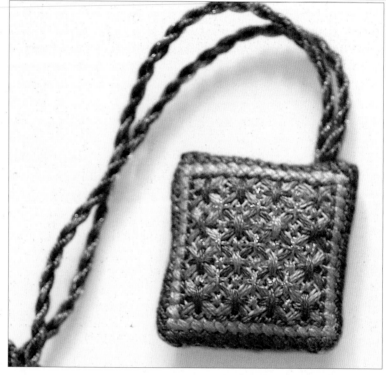

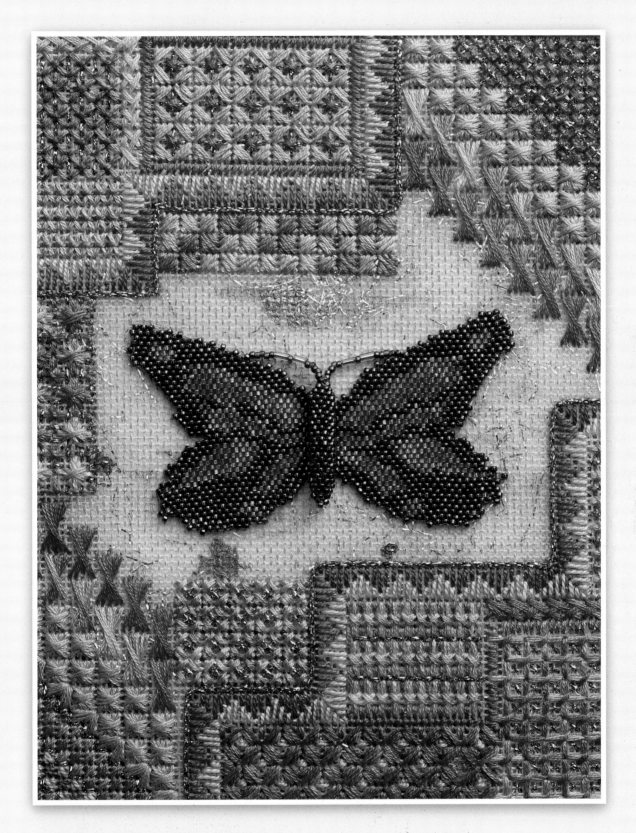

I was given this beautiful beaded butterfly by a friend, and decided to use it as the centre piece of my canvas work.

Casalguidi

Casalguidi had its origin in the small Tuscan village of Casalguidi outside Pistoia in Italy. This form of raised whitework developed in the late 19th century and was extremely popular for embellishing personal articles such as small bags and clothes, as well as household linens. Casalguidi has a very distinctive and unique style and is said to resemble Italy's beautiful marble sculptures. It is first of all distinguished by an area prepared in four-sided stitch which forms the base for the raised embroidery. When the ground is prepared, a design with several raised surface embroidery stitches is worked. One in particular has become known as Casalguidi stitch and consists of bars of thread padding covered with raised stem stitch. Another distinctive element in Casal-guidi embroidery is the beautiful Venetian rosette, which is worked with six buttonhole-stitch petals.

Casalguidi box lid

Level of proficiency

✳ ✳ ✳

YOU WILL NEED

› *25 x 30 cm 28-count*
linen – blue violet
› *Perlé no 12 or stranded cotton*
matching the
colour of the linen
Chameleon perlé no 8
› *2 skeins Wisteria*
› *1 skein Grape Mist*

› *No 26, 28 tapestry needles*
› *Embroidery hoop*
(big enough to take
the whole design)
› *Tissue paper*
› *Black fineliner*

Stitch the background

The background is worked in four-sided stitch before you add the design over it. Trace the background shape (four-sided stitch area) onto tracing paper and position on your fabric. You can tack the outlines if you wish, but I just marked the corners with pins, measuring the frame size as I was going along. If you tack the outline of your background shape, bear in mind that the size of the finished stitching might be smaller depending on your tension.

Four-sided stitch: The top half was worked in loose tension and the bottom half with a tight tension. Make sure your tension is tight to achieve an open background.

Begin in the right-hand corner, as this stitch is worked from right to left. Thread up with no 12 perlé cotton or 2 strands of stranded cotton and start with an away knot (see page 24) about 5 cm to the left of the first stitch. This will ensure that the tail is covered as you are stitching. Just cut away the knot on top of your fabric when you reach it. Each stitch is worked over 4 threads of the fabric. Use the stitch diagram and try to work in a rhythm while keeping your tension even.

Four-sided stitch is directional in appearance, so don't be tempted to stitch the frame going round and round. When you have finished one row turn your work around and work the other way. When you run out of thread, stitch it into the back of your work ensuring that no threads are visible through the holes. Start again in the exact place where you have stopped. Complete the right side of your frame, then the left, before stitching the bottom half.

TIP: I dyed up my own fabric and perlé no 12 for this project. If you have problems finding a coloured even-weave fabric, you can use an ecru fabric, but be sure to choose a matching no 12 perlé. If you want to use a space-dyed thread for this, be sure that it is not too busy as it should form a background to your raised work and not compete with it.

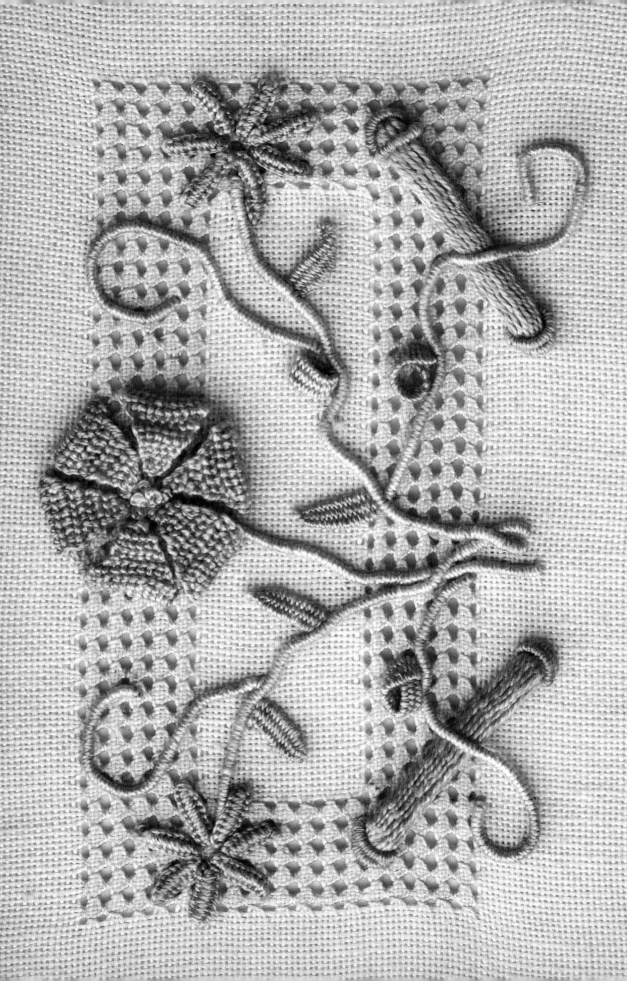

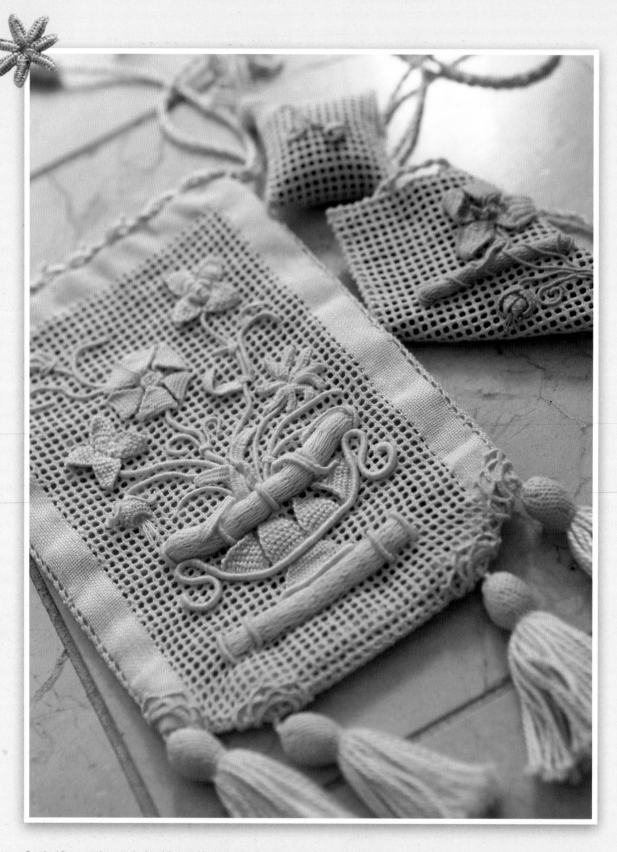

Casalguidi sweetie bag stitched and designed by Myrna Stigling using ecru fabric and thread.

Transfer the design

Transferring the design onto the background can be a painful process, to say the least. I have tried every suggested way and have found none of them entirely satisfactory. Under no circumstances must you try drawing your design onto the stitched background.

The most popular is the **stitch and tear** method. Trace the design diagram on page 118 onto tissue paper using a black fineliner. Position and pin to your background fabric.

With small running stitches tack along the design lines through the paper and fabric, using a sewing thread that will be clearly visible on the background fabric. You do not have to add detail – this is just to give you a rough stitching guideline. You would, for example, only use one running stitch to indicate the outer edge of the leaf of the Venetian rosette.

Place your fabric onto a towel and run a pointed needle along the tacked lines to tear the paper.

Carefully tear away the tissue paper a little at a time without lifting your tacking stitches. This can be tricky, so be gentle.

Stitch the Venetian rosette

The Venetian rosette consists of six detached buttonhole-stitch triangles (see page 118) completed in a hexagon shape. The outer edges of the rosette leaves do not touch, but are worked slightly smaller to give the hexagon a rounded effect.

The triangles sit on top of the fabric and are attached to the fabric with the foundation bar at the base of the triangle, and at the point in the centre. They can be quite tricky to do; I would suggest that you do a trial run first.

Start with two straight stitches at the base of a triangle using perlé no 8 Wisteria. These must be secured well as you will be tugging at them while doing the buttonhole stitch. Make 10–12 buttonhole stitches depending on the width of the stitch. Keep your thumb on the stitches while you work, as this will prevent distortion of the foundation stitches. Be sure not to stitch through the fabric. Work the next row in the opposite direction and decrease by two stitches.

Continue in this way until you have only one stitch left. I prefer my triangles to be a little longer than the design, as this gives a more raised effect when stitched down.

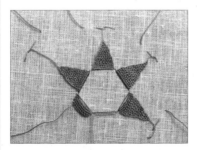

Do not stitch each triangle down in the centre after you have completed it, but pin it out of the way until you have completed all six. You might find that your first triangle is not as perfect as the last and that you want to replace it as your technique improves with each triangle.

Detached buttonhole is all about practice.

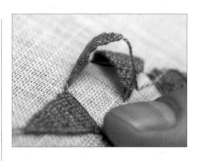

After completing all six triangles, attach them at the centre, leaving a centre opening. Fill the centre opening with French knots in perlé no 8 Grape Mist

Work the daisies

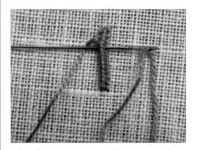

Double buttonhole bar: Note that enough space must be left on the bar to fit in another row of stitches on the other side.

The daisies are worked in perlé no 8 Wisteria by stitching seven double buttonhole-bars (see page 118) in the shape of a flower. Start with two straight foundation stitches. Come out about 2mm below your first entry stitch. This will anchor the petals on both ends. Buttonhole stitch over the bars, but be sure not to stitch through the fabric.

Do not pack your stitches very tightly, as you will have to fit in the same number of stitches on the other side of the bar. When you come to the end, enter the fabric again about 2mm below the last entry stitch. Turn your work around and repeat the process, stitching over the bar between the buttonhole stitches of the first row. Complete the other six petals in the same way.

Padded, raised-stem band

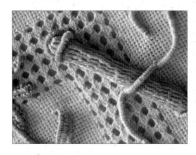

The padded, raised-stem band is probably the most distinctive feature of Casalguidi embroidery, and is even sometimes called the Casalguidi stitch.

1. Begin by cutting 15x15 cm lengths of perlé no 8 padding thread (use any colour as it is going to be covered). Fold in half and sew the looped ends to the fabric with sewing thread. Couch the padding thread to your fabric at intervals, but bring your needle out under the padding and go back in the same hole to ensure that the padding has a rounded appearance. When you come to the end, wrap the bundle of threads tightly and end off before cutting off the excess padding threads.

2. Cover the thread padding with satin stitch using 6 strands of stranded cotton in a colour slightly different from Wisteria. If the colour is too similar, you will find it difficult to see the foundation stitches for the raised stem. If your colour is too much of a contrast, the foundation stitches for the raised stem might show through your stitches. You can also use a perlé no 8, but I found that stranded cotton gives a more even finish and pads much quicker.

3. Next, make the foundation stitches that will anchor the stem stitch, using perlé no 8 Wisteria. Begin the first, and

end the last stitch, a few millimetres from the end, as you do not want your stem stitches to slip off. Stitch them about 3-4mm apart at a right angle to the padding stitches. Your stitches must not be too tight, as you will have many stem stitches passing over them.

4. Thread a tapestry no 26 needle with perlé no 8 Wisteria. Work stem stitch (see page 117) over the foundation stitches from left to right. Remember that no threads are taken along the back of the work. Most embroiderers would claim that this can only be worked in one direction, but by working stem stitch in one direction and outline stitch (see page 117) in the other, you solve the problem. Many embroiderers regard stem stitch and outline stitch as one and the same, but they are not. With stem stitch your working thread is always to the right of the needle and with outline stitch it's to the left. Begin your stitching on the side furthest away from you. After stitching every row push the last one back with your needle to pack them closely. Try keeping your ends nicely rounded by finishing not too close to the padding.

1 2 3 4

1. Padding thread couched down
2. Thread padding covered with satin stitch
3. Foundation stitches for the stem stitch
4. Raised stem stitch completed

5. Cover the ends of the raised band with two bullion knots making sure that you have enough wraps around your needle to cover the bar. Bring the needle through the fabric on one side of the bar. Insert it on the other side, letting the point emerge in the same place as the thread but not pulling through. Coil the thread around the needle (about 20 times) and pull the needle through the coil while holding the coil between your index finger and thumb. If some of the coils are slightly loose, simply twist them in the right direction with your fingers. Insert the needle on the other side to bring the knot over the bar.

Wrapped stems

To make the stems I used continuous wrapping – the thread is wrapped around separate core threads and then couched down.

Thread the needle with 2 lengths of perlé no 8 Grape Mist twice the length of your stem plus 10cm for handling. Pick up about 2 fabric threads where your stem is about to start, take the needle out and adjust the thread until the ends are the same length. This will form the core of your stem.

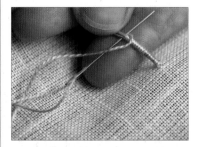

Continuous wrapping: Hold on to the base threads with your left hand while wrapping with your right.

Thread a no 28 tapestry needle with a separate strand of perlé no 8 Grape Mist, about 4 times the length of your stem. Use enough thread as you cannot start

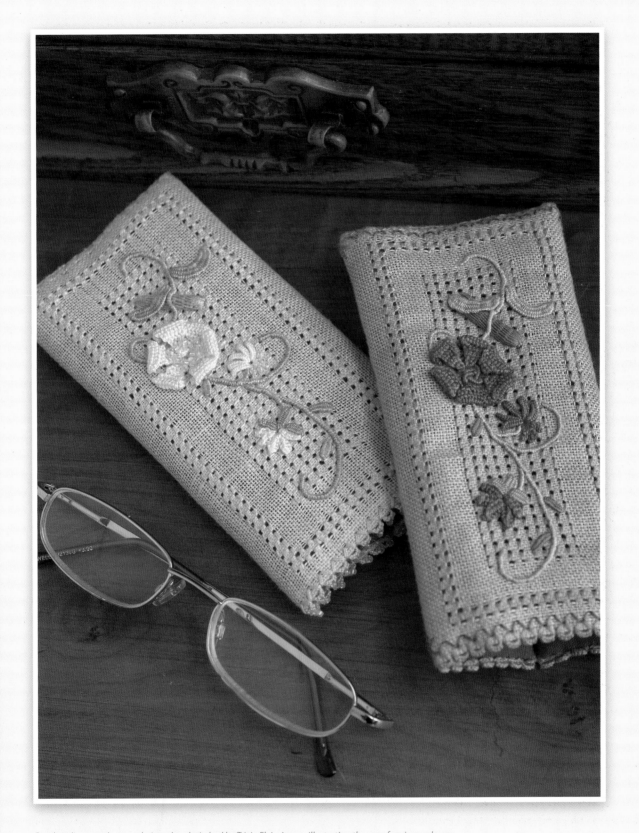

Casalguidi spectacle cases designed and stitched by Tricia Elvin Jensen illustrating the use of various colours.

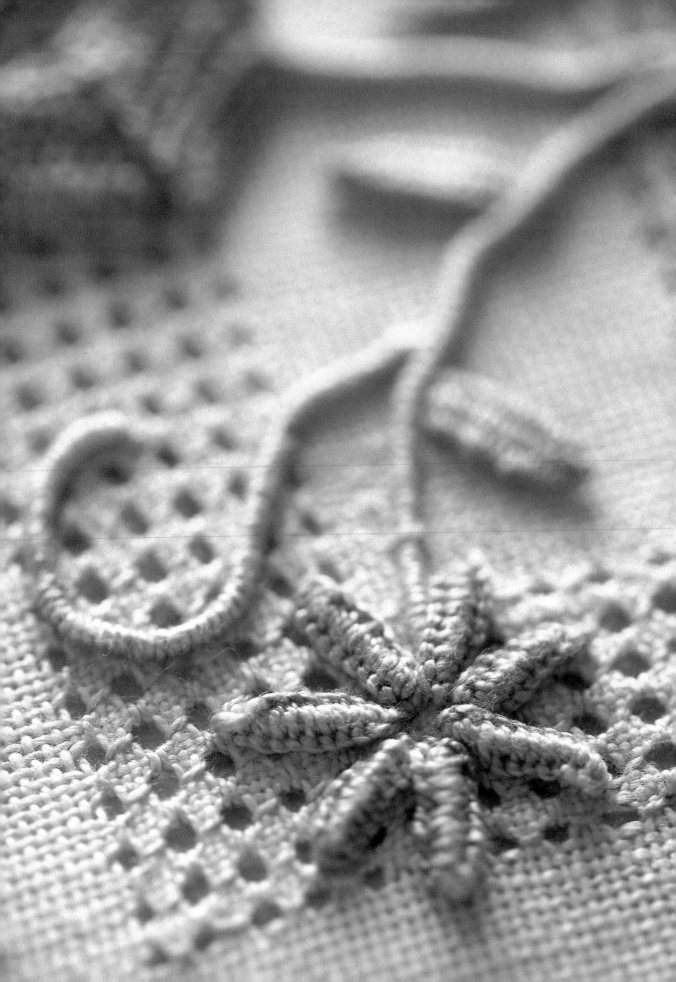

with a new thread if you run out. Bring the thread out in the same hole as the core thread.

Rest the core thread on the index finger of your left hand, holding it down with your thumb. Keep the core thread taut and run the tapestry needle under and over to form a wrapped stem. When you have reached the required length, make a buttonhole stitch to prevent the wrapped thread from unwinding.

Shape and pin your stem in any position and couch down at intervals. I finished all my stems and then manipulated them until I was satisfied with the result. Take the core and wrapping threads to the back of your fabric and stitch into existing work.

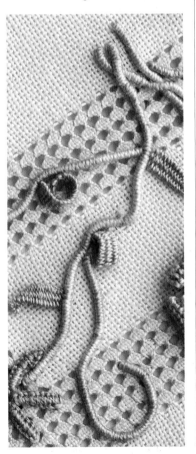

Woven picots

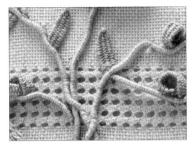

Woven picots can be either long or short and make wonderful leaves or leaf petals.

For short woven picots, insert a pin into the fabric following the direction and length of the leaf. The head of the pin must be at the tip of the leaf and the point at the base of the leaf. Thread a needle with perlé no 8 Grape Mist, and bring it out about 3mm to the left of the pin at the base of the leaf. Take the thread around the head of the pin and enter again on the right-hand side about 3mm away from the pin. Bring it out again where the pin has emerged from the fabric and take around the back of the pin head to form three foundation threads.

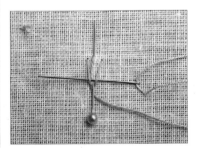

Begin to weave from the head of the pin by picking up the foundation stitch on the right, going over and under from right to left and back again. Remember not to go through the fabric.

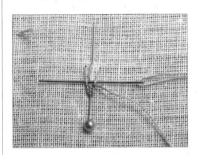

When you've completed the picot, take the thread to the back of the fabric. Remove the pin and manipulate the picot into a leaf shape.

Long woven picot is stitched in exactly the same way as the short woven picot, but the picot is longer. Once completed, you can manipulate the picots to form little buds, and attach the ends to the fabric.

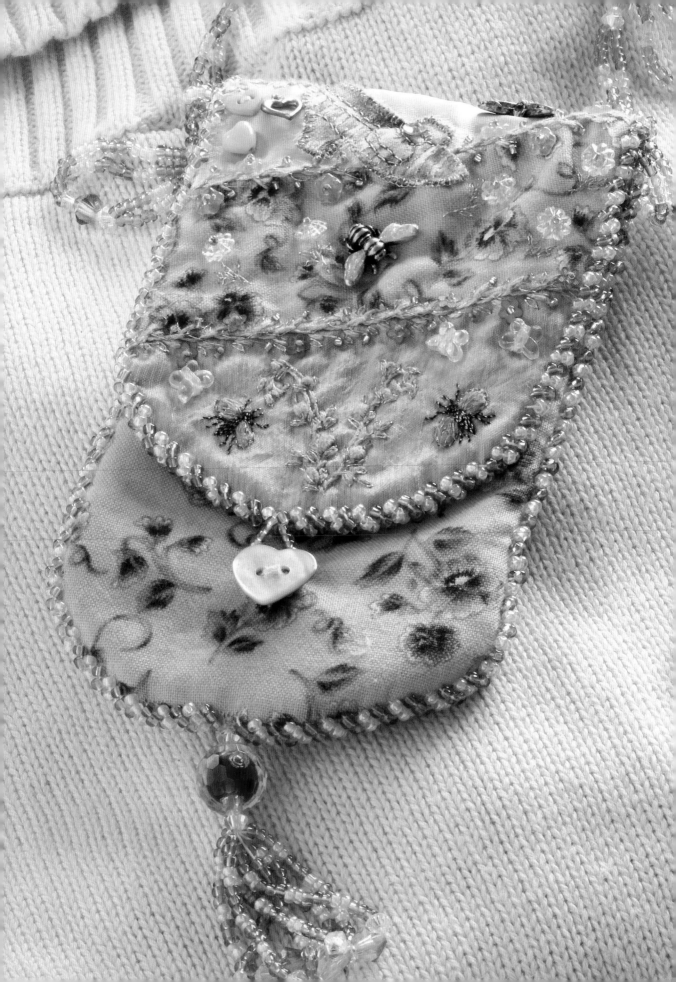

Crazy patchwork

Crazy patchwork is a unique way of joining different types of fabric at random to make a single item and decorating it with embroidered embellishments on every seam and patch. This wonderful pastime originated during the American Civil War when odd bits of cloth were pieced together to recycle clothing and bedclothes. Either loved or despised by needlewomen of the time, it soon became an accepted form of needlework in its own right, with the stitches and embellishments constituting a veritable art form. Crazy patchwork or crazy quilting reached its peak in the 1880s and was very popular until the late 1920s. Recently there has been a renewed interest in crazy quilting. Embroiderers today use velvets, satins, silks, brocades, cottons and hand-dyed fabrics embellished with lace, pearls, seed beads, silk ribbon and charms. I love this form of stitching as you can really go to town and nothing is too over the top! Complete kits are available (see suppliers list page 128) which saves you the trouble of finding all the different elements that go into making a crazy patchwork item.

All crazy-patchwork items in this section were designed and stitched by Gay Booysen

Cellphone pouch

YOU WILL NEED

Fabric
› *10 x 25cm calico cut to pattern size for base*
› *20 x 25cm pretty fabric for lining of the pouch and pocket*
› *10 x 13cm floral fabric for pocket front*
› *Batting*
› *Assortment of printed fabric off-cuts (small prints as the pouch is small)*
› *Assortment of lace, silk, satin or taffeta off-cuts*
Embellishments
› *A small lace motif*
› *Ric-rac or lace*
› *Flowers, butterflies and fabric shoe for appliqué*
› *Small sequins, beads, charms and buttons*
› *Beads in contrasting colours – size 11 for the cord*
Chameleon threads
Stranded cotton Coral, Fern and Erica (choose threads and colours according to your fabric)
Needles
› *No 8 crewel needle*
› *No 8 straw needle size 8*
› *Chenille needle for silk ribbon work*
› *Beading needle*

› *Silk ribbon in matching or contrasting colours*
› *Metallic thread*
› *Sewing machine*
› *Iron*

Assemble the crazy patchwork

1. Enlarge the template on page 124 as required and cut the base for the crazy patchwork from calico.

2. Place the fabric off-cuts you are going to use in sequence with good contrast from one to the next. Take into account that the last off-cut will fold over and be next to the inside pocket fabric. You do not have to cut anything to the correct size as you will trim it later.

When placing the off-cuts ensure that you have a good contrast between fabrics

3. Place the first off-cut right side up at an angle on the calico base and pin.

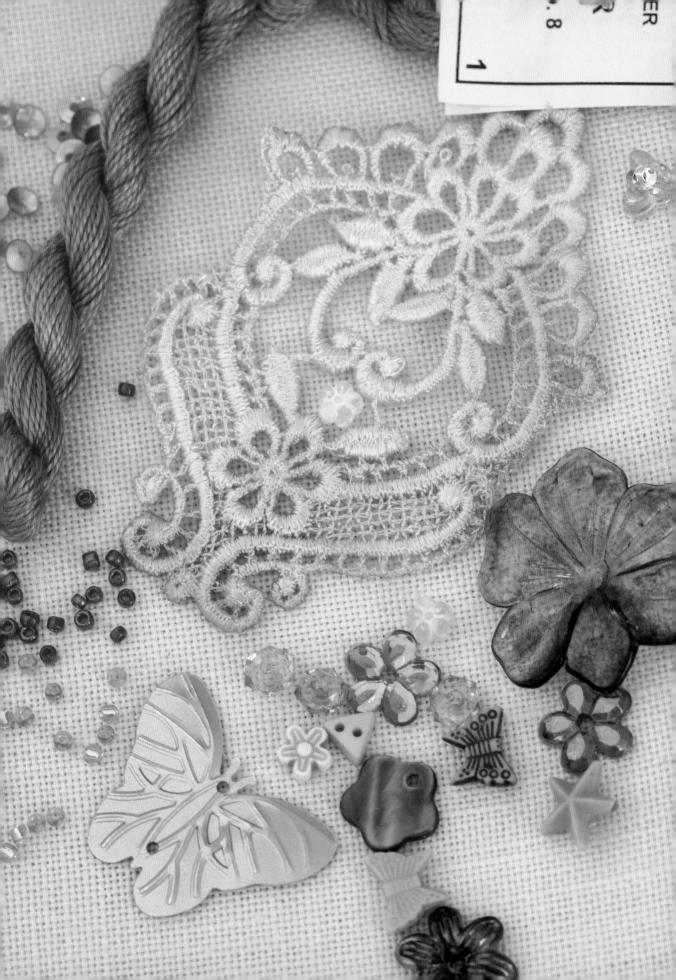

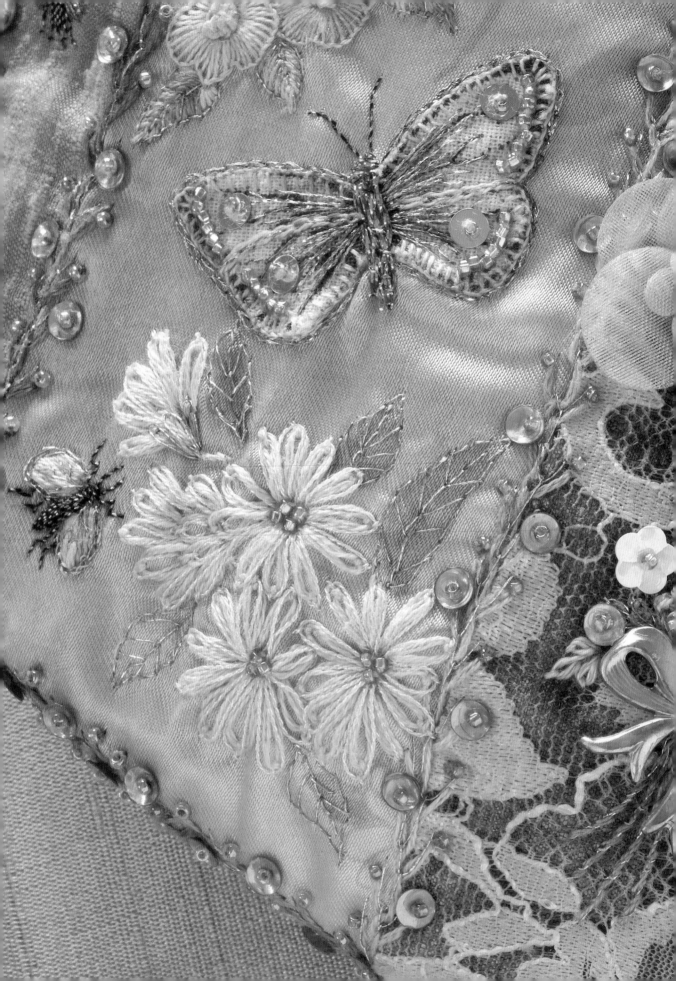

4. Place the second off-cut on the first, right sides together, and stitch. Trim the seam, fold back the second off-cut and iron. Repeat with further off-cuts until the calico base is covered.

5. Trim to the shape of the calico. Overlock the stitched piece to keep all layers together.

6. Using a big tacking stitch, carefully tack a 1cm seam allowance around the edge of the crazy patch piece to serve as a guideline when doing your embroidery, as you do not want the embroidery to go into the seam allowance.

Embroider and embellish

1. Decorate seam lines with pretty braid, lace or ric-rac and add embroidery stitches (use the illustrations below as a guide), beads and sequins. Good stitches to use are feather stitch, chained feather-stitch, fly stitch, herringbone stitch, chevron stitch, blanket stitch, wheatear stitch and lazy daisy stitch. These can be enhanced with beads and metallic threads. Space-dyed threads work particularly well for the embroidery and hand-painted silk ribbon can be used to add texture.

2. Embroider small flower sprays, insects, butterflies and so on in open spaces. Spiders webs and fans are traditionally used in crazy patch, and initials are embroidered to personalize an item. You can even embroider the motifs printed on the fabric.

3. Once the embroidery is done, the embroidered piece can be further embellished with small buttons, charms, lace motifs and appliqué motifs – the sky is the limit!

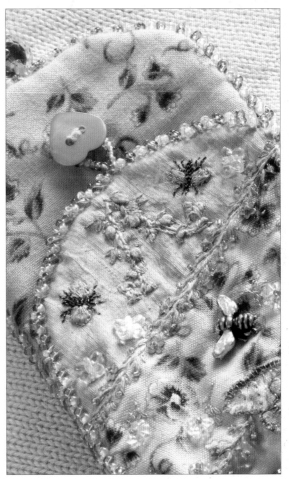

This pouch (above and left) was decorated with embroidered buttonhole flowers, lazy-daisy flowers, silk ribbon spider-web roses, small insects and an embroidered initial. A small antique fabric shoe and butterflies were appliquéd. A lace motif was also couched in place and further enhanced with beads and metallic thread. Stitch combinations and ideas are given on the next few pages.

Embroidered motifs for open spaces

FLOWER SPRAY

Stems – stem stitch
Small leaves – lazy daisy stitch
Rose buds – 2 bullion stitches
with lazy daisy stitch leaves
Bow – chain stitch

FLOWER VINE

Vine – stem stitch
Small leaves – lazy daisy
Flowers – lazy daisy
using 4 mm silk ribbon

BUTTERFLY

Wings - lazy daisy stitch
(top wings larger than the
bottom wings)
Feelers – straight stitch
with French knots or beads
at the top of each feeler.

SPIDER'S WEB

No crazy patch is complete
without a spider's web!
Use silver or gold metallic
thread. Make the spokes
of the web with 3 long
straight stitches.

Starting near the centre of the web, work long straight stitches to form the web. As you reach a spoke, make a small stitch around the spoke through the fabric. The long spokes and spiral stitches may also be couched with tiny straight stitches. If you wish, add a small spider using 2 small black beads with 8 small straight stitches for the legs.

TREE

Embroidering a tree in an
empty space is quite
traditional.
Trunk and branches – filled with
stem stitch
Leaves – lazy daisies, French
knots or straight stitch.

SMALL FAN

Small fans are often used in
crazy patchwork.
These can be worked in two
ways. Gather a small piece of
lace into a fan shape, attach
and embellish with embroi-
dery stitches and beads.

Or embroider directly onto the crazy patch as follows: stitched with 7 straight stitches finished with a row of chain stitches to form the top of the fan. Small straight stitches can be stitched between the large ones.

SMALL BOW

Work 2 lazy daisies and a French
knot to form the centre of the
bow. The bow tails can be
stitched with 2 straight stitch-
es. A row of small bows can be
stitched along a seam line with great effect.

SMALL FLOWER

Embroidered small flowers
using buttonhole stitch
and add leaves using closed
fly-stitch.

INITIALS

These will personalize your work. Embroider an initial in stem stitch using one strand of thread and whip with gold metallic thread. Add little bullion rosebuds with lazy daisy leaves.

SMALL INSECTS

Body and head –
satin stitch using black
and gold metallic thread.
Legs and feelers –
back stitch using black
and gold metallic thread.
Wings – satin stitch in space-

dyed thread, then decorate with gold metallic thread using small straight stitches. Finally, back stitch around each wing using gold metallic thread.

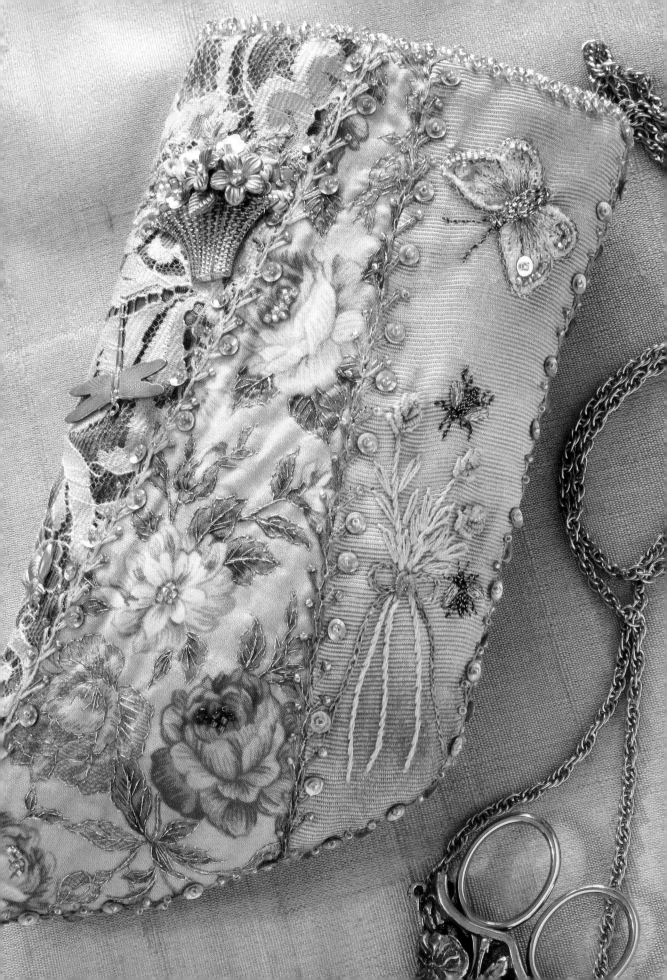

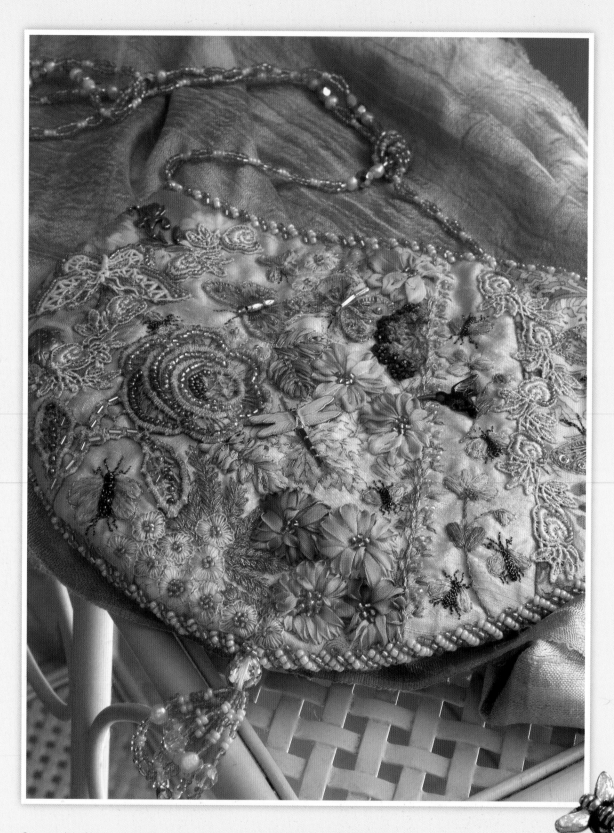

Crazy-patchwork evening bag and spectacle case (page 59) designed and stitched by Gay Booysen

Make the cell-phone pouch

1. Cut fabric lining and batting to the size of the finished embroidery. Enlarge template on page 124 as required and cut the pocket piece – once from the left-over lining fabric and once from a printed floral fabric for the pocket front.

2. Place 2 pocket pieces right sides together and stitch seam at the straight edge (see diagram 1), turn right side out and press. Add a small piece of lace to the top edge for decoration if you prefer.

3. Assemble in the following order: batting, lining (right side up), pocket (right side up) and the crazy-patch piece (right side down). Pin all these layers together so that they do not shift. Stitch along the sewing line, leaving a small opening (see diagram 2). Trim the seam and clip carefully around the edges. Turn right side out, press carefully and close the opening with small stitches.

4. Finish off with top stitch, feather stitch with beads or a beaded rope edging and a tassel. Fold the pocket over and attach a small button or press stud to close it. Should you wish to hang the pouch around your neck, attach a gold cord or make a beaded cord.

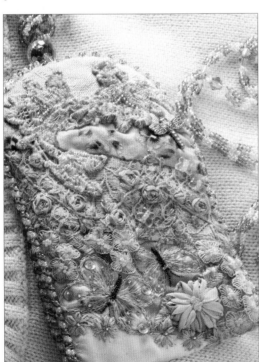

Suggested stitch combinations

COVERING THE SEAM LINES

Buttonhole stitch

Chevron stitch

Herringbone stitch

Straight stitch

Feather stitch

Fly stitch

Lazy daisy stitch

Diagram 1

Diagram 2

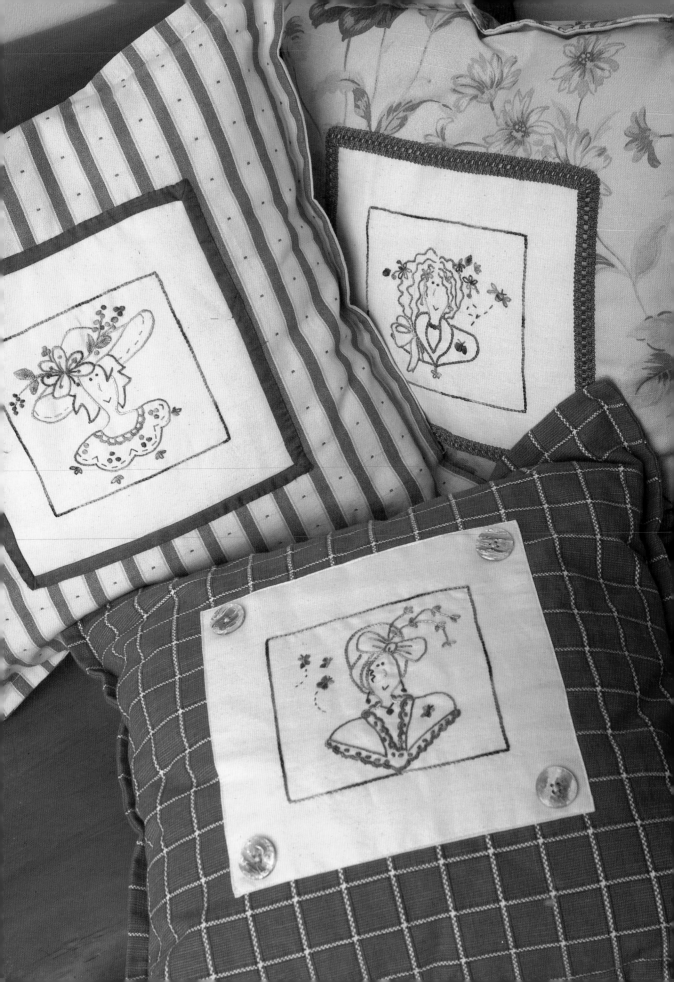

Freestyle embroidery

Doing freestyle embroidery is in many ways like having a blank sheet of paper in front of you before painting or drawing a design on it. Freestyle embroidery gives you enormous freedom as you are not bound by any rules. Many people find it quite daunting, but because there are no rules you can experiment to your heart's content. Freestyle embroidery is a good way to try out various stitches and different types of thread. I used very basic embroidery stitches for my Three Lovely Ladies and they were stitched in no time at all. It is a project that travels well as there is no counting involved. I stitched these while on a bus tour in Whales. The effect is charming and the embroidered designs can be used on cushions, bags, quilts, tea cosies and so on. You can either follow my stitch guide or just do your own thing – that is what freestyle is all about!

Three lovely ladies

Level of proficiency

✷

Before you start

Transfer the three designs on pages 126-127 onto the fabric squares. Place the fabric squares with the designs into an embroidery hoop one at a time and follow the instructions below as a guide for the embroidery. The stitches are all illustrated on pages 114-119.

YOU WILL NEED

› 3 x 25 x 25cm cotton fabric – cream coloured
› Sharp embroidery scissors
› Small clip-frame embroidery hoop
› No 3 crewel needle

Chameleon perlé no 8
› *Amber*
› *Baobab*
› *Cleome*
› *Mahogany*
› *Raspberry*
› *Sage*
› *Sea Sand*
› *Summer Garden*

Lady with wide-brimmed hat

STITCH AND COLOUR GUIDE

Face and nose – Stem stitch in Sea Sand
Mouth – Straight stitch in Raspberry
Eye – French knots in Mahogany
Hair – Stem stitch in Baobab
Hat – Stem stitch in Cleome
Flower in the hat
Petals – Stem stitch in Summer Garden
Stamens – Stem stitch and French knots in Summer Garden
Stems – Stem stitch in Sage
Leaves – Fly stitch in Sage
Buds – Satin stitch in Summer Garden

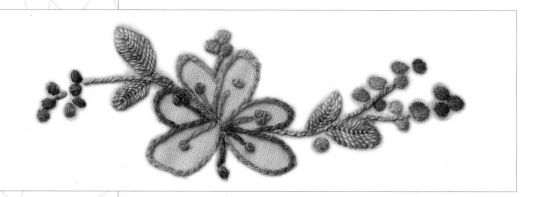

TIP: When stitching the earrings, butterflies and the bee, try to use the same colour sequence on the left as on the right.

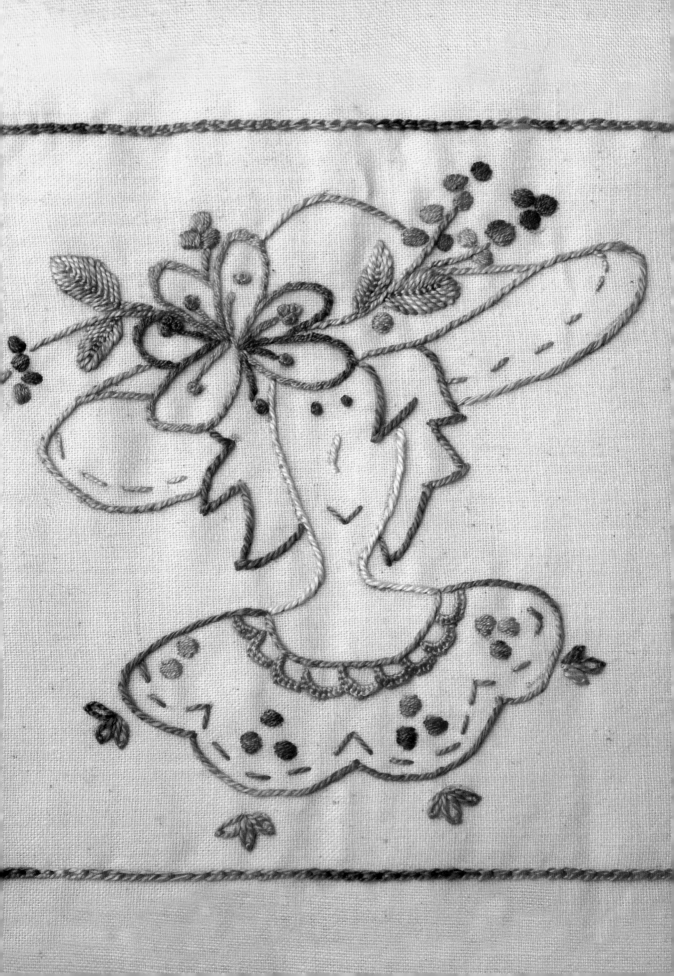

Lace collar
Neck line – Stem stitch in Cleome
Edging – Buttonhole bars in Cleome

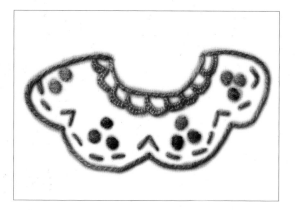

Dress
Outline in stem stitch and fill with satin-stitch dots in Summer Garden; finish with four lazy daisy flowers using Summer Garden.
Frame – Chain stitch in Summer Garden

 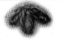

Butterflies
Wings – Straight stitch in Summer Garden
Bodies – Bullion knots in Summer Garden

Lady with a bow in her hat

Face and nose – Stem stitch in Sea Sand
Mouth – Straight stitch in Raspberry
Eyes – French knots in Mahogany
Hair lock – Stem stitch in Mahogany
Hat – Chain stitch in Cleome
Bow – Stem stitch in Summer Garden
Flower spray – Stems in stem stitch and leaves in lazy daisy using Sage
Earrings and necklace – Straight stitch and satin stitch in Summer Garden

Dress collar
Outline – Stem stitch in Amber
Lace edging – Buttonhole bars and French knots in Amber
Frame – Chain stitch in Summer Garden

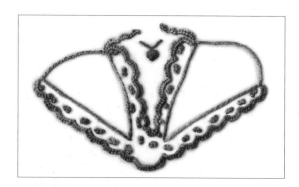

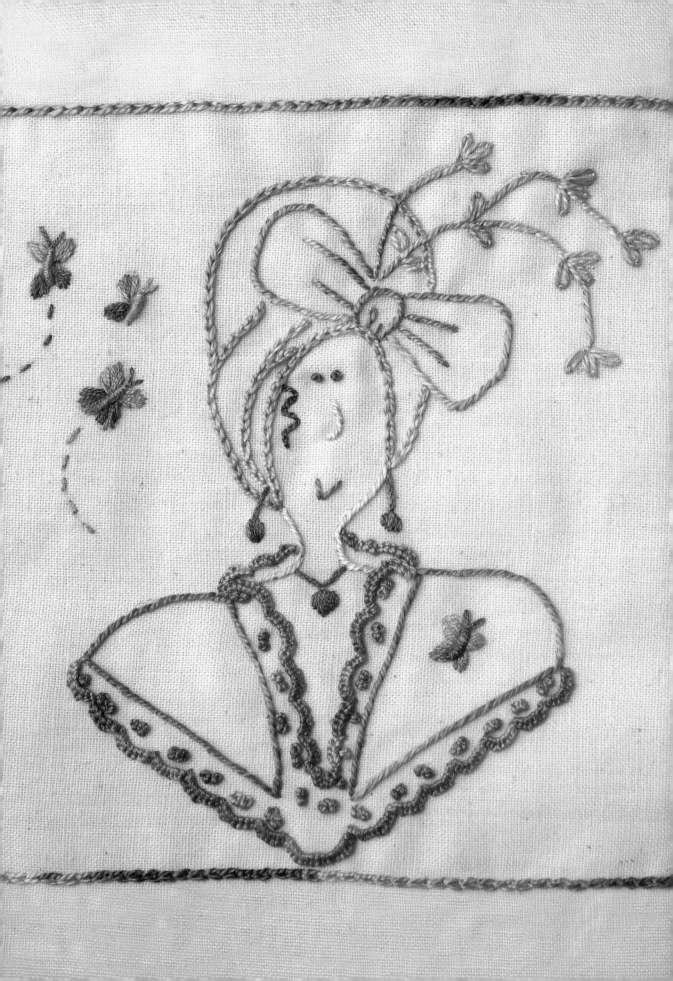

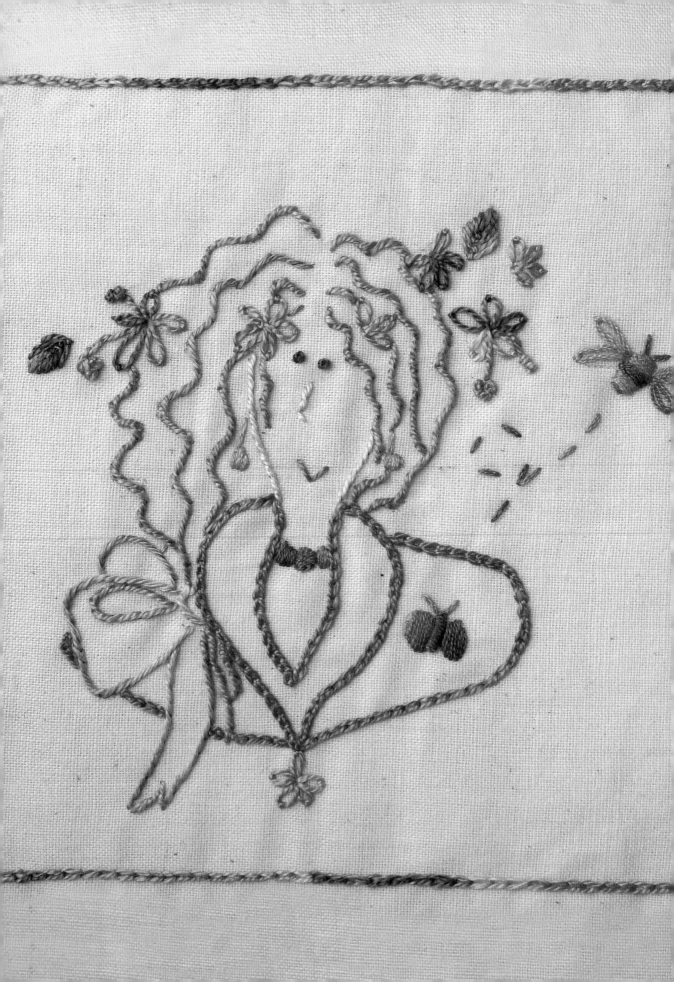

Lady with curly hair

Face and nose – Stem stitch in Sea Sand
Mouth – Straight stitches in Raspberry
Eyes – French knots in Mahogany
Hair – Stem stitch in Baobab
Flowers in hair – Lazy Daisy, French knots and Fly stitch in Summer Garden
Earrings – Straight stitches and Satin stitch in Summer Garden

Beads – Satin stitch in Summer Garden
Bow on dress – Stem stitch in Sage
Dress – Chain stitch Raspberry

Butterfly brooch
Wings – Satin stitch in Summer Garden
Body – Bullion know in Summer Garden
Feelers – Straight stitches in Summer Garden

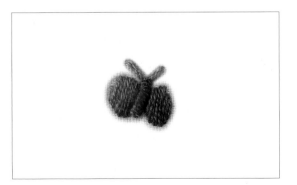

Bee
Wings – Lazy Daisy in Summer Garden
Body – Satin stitch in Summer Garden
Feelers – Straight stitches in Summer Garden
Flower on collar – Lazy Daisy in Summer Garden
Frame – Chain stitch in Summer Garden

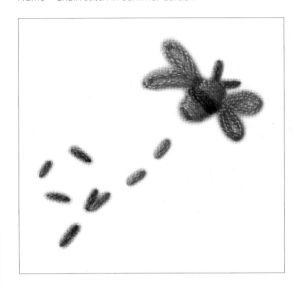

Goldwork

Gold thread has been used to embellish fabric and clothing as far back as biblical times. It has since been associated with wealth and status and has, therefore, adorned garments and textiles for royalty and the clergy. Church embroidery and goldwork flourished in the Middle Ages and it was then known as English work or *Opus Anglicanum*. The Syon Cope is probably the most famous example from this period and can be seen in the Victoria and Albert Museum in London.

During the Elizabethan era gold threads were used in domestic embroidery and are seen in many Elizabethan and blackwork embroideries. Goldwork has once again become a very popular form of embroidery and combines particularly well with space-dyed threads. Before embarking on a goldwork project, ensure that you have the right tools and materials, as some tools and materials are used in goldwork only and not in any other form of embroidery.

On the next pages I discuss what you need in addition to normal embroidery materials.

A STRONG AND STURDY HOOP

It is of the utmost importance to have a strong, sturdy and preferably a deep hoop. I use a 30cm deep hoop with a base as this sits comfortably on my lap. You have to make very sure that your fabric is really taut at all times, as metal threads are heavy and will easily distort the fabric.

SCISSORS

You will need sharp-pointed scissors for cutting the metal threads. Please do not be tempted to use your best embroidery scissors for cutting both the metal threads and the embroidery thread, as the metal thread will blunt them.

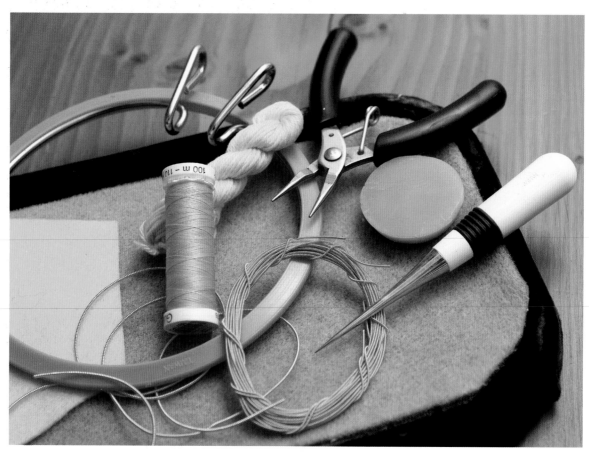

NEEDLES

Embroidery or crewel needles work well as they are fine and have large eyes. I find that the finer the needle the better and a no 9 or 10 embroidery or crewel needle is perfect.

THREAD FOR SEWING DOWN YOUR METAL THREADS

In goldwork metal threads are couched onto the fabric using sewing thread. It is therefore very important to use a sewing thread that will match your metal threads as closely as possible. I used Gutermann 488 100% polyester thread.

STILETTO

I was lucky to find a stiletto in an embroidery shop – these are sometimes very hard to come by. This is a very handy tool when making a hole for plunging your metal threads.

LASSO

A lasso is used to pull the metal threads to the back of your work. It is made from a large chenille needle and a piece of very strong, waxed thread. I use a perlé no 8. Thread both ends of the thread into the eye of the needle in opposite directions. The metal thread is pushed through this loop which is tightened.

Now hold on to the ends of the waxed thread while pulling the needle through your fabric. The loop will ensure that the metal thread is pulled through the fabric at the same time.

use the most popular threads in this design, but there are many more available. It is extremely important that you buy good quality gold threads, as cheaper versions tarnish quickly.

BEESWAX

In goldwork stitching through padding and around metal threads results in thread fraying, therefore all sewing thread is waxed to strengthen it.

When you are using cotton string for padding, this must also be waxed thoroughly.

VELVET BOARD

A velvet board is very handy for cutting the purls as they tend to jump all over the place if not cut on a hard surface. You can make this yourself by covering the lid of a 2-litre ice-cream container with velvet fabric.

YELLOW FELT

All shapes are padded with yellow felt before the metal threads are couched down.

SOFT COTTON PADDING

This is a fairly thick soft cotton thread that is waxed and used in padding when doing purl work.

TWEEZERS

A pair of tweezers is very helpful in manipulating threads, for example to make points and corners in joining together pearl purl.

METAL THREADS

Buying metal threads can be bewildering as there is a large variety in threads as well as huge variance in quality. I tried to

IMITATION JAPANESE GOLD (JAP) consists of a core of silk cotton or synthetic fibre wrapped in a metallic polyester strip. Jap is always couched in pairs and comes in various numbers indicating its thickness. The higher the number, the thicker the thread. I prefer using the English version of this thread made by Benton and Johnson in London. It is graded from T69 to T72 and is a bit duller than other threads.

PURLS

This thread is made as a tight coil from a fine round wire, and is hollow inside. It is cut into sections and used like beads. **Smooth** and **rough** purl is either shiny or matt in appearance and comes in a variety of colours. **Check** purl is coiled on a three-cornered needle and has a very different texture. It is also used like a bead. **Pearl** purl is much thicker in appearance and gives the impression of small pearls next to each other. This thread is mainly used for outlining designs.

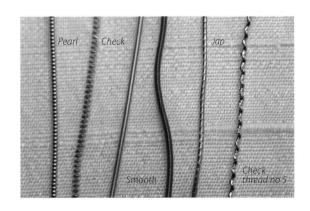

Pearl Check Jap

Smooth Check
 thread no 5

Basic goldwork techniques

Not only do you need special tools and materials for goldwork, you also used special techniques.

FELT PADDING

All goldwork is first padded with a layer of yellow felt. If height is needed the padding can even consist of several layers. The design is layered with pieces of felt from small to large to achieve an evenly rounded shape. It is very important that the padding should be slightly smaller than the actual design and fall inside the design lines. This is to leave room for your pearl purl outline. White felt is used when you are stitching with silver metal threads.

SOFT COTTON PADDING

Soft, yellow cotton is used for stitching stems or narrow areas and would be covered with purl cut-work. The cotton thread is waxed thoroughly to make it sticky. Several lengths are then added together until you achieve the required thickness, and pressed into the right shape. Couch the cotton threads down onto your design with stitches about 2mm apart. If the stem is narrower in some places, some threads can be cut away to

accommodate this. Lift the threads up and cut away until you get the desired thickness. Also trim some threads at the top and bottom of the stem to ensure an even slope. This will stop the purls from falling off the padding.

LAID WORK

Laid work is done using 2 strands of imitation Japanese gold. This is couched over the felt padding. As the threads are couched the tail ends are left on top of the fabric, and later plunged to the back. The pair of threads is couched using the waxed sewing thread at intervals of about 3mm. When turning a corner, pinch the two threads together using tweezers and first stitch down the outside thread followed by the inside one.

Now stitch your second row of threads by bringing your needle out on the outside and then placing it between the two rows of threads. This will ensure that the threads are pulled together neatly. Your couching stitches must now fall between the stitches of the previous row like a row of bricks.

PLUNGING

Plunging is done with a lasso. You can make a hole with a stiletto where you want to plunge your threads. Catch the tip of

one thread with your lasso and pull the two ends of the lasso thread tight. Gently pull the needle through to the back, taking along the gold thread one at a time. When you have pulled all the gold threads to the back, fold them back and sew them down. Trim away any excess.

CUTWORK OVER SOFT STRING

Cutwork using smooth or rough purl can be quite tricky. You want the purl 'beads' to fold around the cotton string padding at a 45 degree angle. Getting the purls just the right size can be difficult. If the stem is one thickness a sample piece can be cut to give you a guideline for the rest. I start in the middle and work upwards, turn my work upside down and repeat on the other side. Enter and exit your needle as close to the padding as possible as this will ensure a beautiful rounded effect. If the purls crack as you sew them down, they are too long and should be replaced.

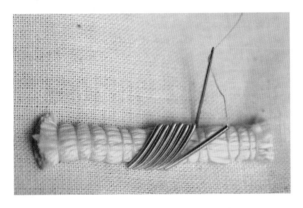

CHIP WORK

I love chip work as it gives a wonderful glitzy effect. It is done with check purl cut into small 'beads', used to fill small areas. The beads of check purl must be of similar length and width.

Once cut they are stitched down randomly like small beads until they fill the whole area.

STITCHING WITH PEARL PURL

Pearl purl is used to give a beautiful outline to your work. This can be done around some areas filled with gold thread or even long and short stitching. Pearl purl is not plunged and is cut to the exact length to fit the design. First cut the pearl purl to give a neat edge, showing a full bead. Now couch down pulling the waxed sewing thread into the groove between the first two beads. You will hear a clicking sound as the threads go in. You do not want to see any threads on top of the pearl purl. Continue by stitching into every 3rd or 4th groove. Once the design is outlined the pearl purl is cut in the same way as before. The pearl purl bends easily and can be folded to make a neat corner.

LONG AND SHORT STITCHING OVER FELT PADDING

I used long and short stitching to fill in the leaves and petals. The new Shades of Africa range by Chameleon Threads have been especially dyed up for this purpose, as the colours blend very delicately from dark to light.

Botanical design

Level of proficiency

✳ ✳ ✳

YOU WILL NEED

Fabric
› *35x35cm écru-coloured silk*
› *35x35cm pre-washed calico for backing*
Chameleon Threads
› *Shades of Africa Soie de Paris – Camellia*
› *Shades of Africa Soie d'Alger – Knysna Forest*

› *Yellow felt for padding of the design*
› *Yellow cotton thread for padding of the stem*
› *No 6 rough purl gold and red-orange*
› *No 6 bright check purl*
› *No 1 pearl purl*
› *T70 Imitation Japanese gold*
› *Check thread no 5*
› *4 small sequins*

Colour variation

Instead of Camellia, use Highveld Storm (left) or Protea (centre) together with Knysna Forest (right)

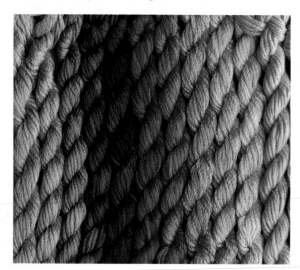

1. Follow the instructions as given for the Jacobean embroidery to transfer the design on the opposite page onto the centre of the silk fabric (see page 92). Place both the silk with the design and the backing fabric onto a hoop and pull very taut.

2. Trace the design onto a separate piece of paper and cut out shapes l, 2, 4, 5, and 6. Use these as templates for the felt padding, cutting the shapes slightly smaller than the actual design as it is important for design lines to still show after the felt has been applied. If not, you will not have any room for the pearl purl when outlining the shapes. Apply the felt padding to all the petals and leaves (1, 2, 4, and 5). Cut out the felt calyx and redraw the centre lines of the design onto the felt. Stitch into place as shown in felt padding (see page 74).

Wax a length of soft cotton string and keep on folding it in half until you have the right thickness for your stem. I used about 20 threads. Shape with your fingers until round and stitch down following the instructions under soft cotton padding (see page 74).

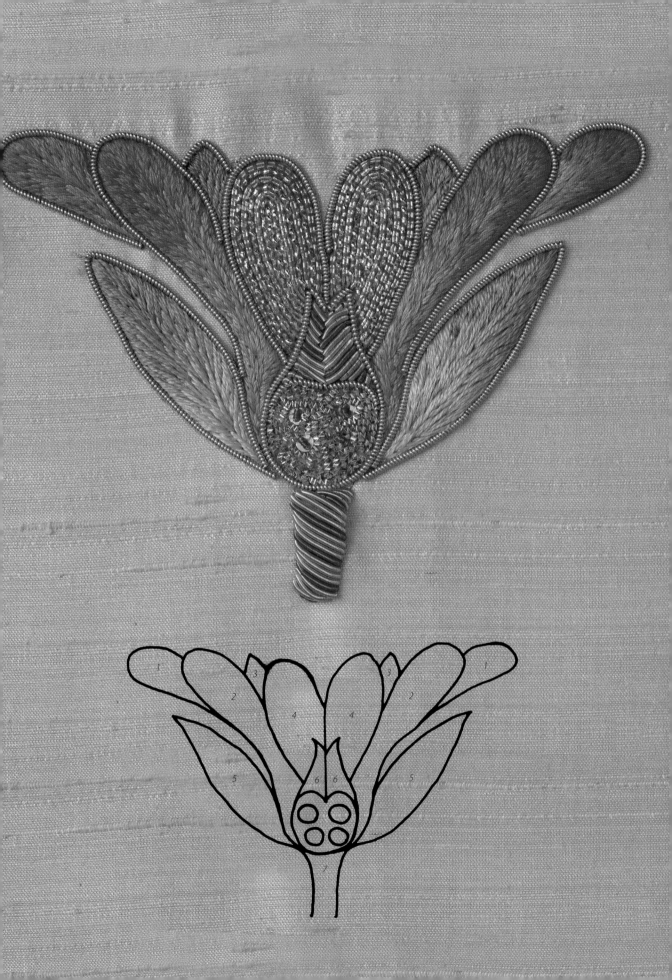

3. Start with the petals to the back of the design (always do this). Lightly pull the silk thread through the beeswax to make it less springy. Outline petals I in split stitch using 2 strands of Camellia no 5 silk thread. Shade these petals working long and short stitch by using first 2 strands of Camellia no 5, followed by Camellia no 4 silk thread. Note that only the pure silk (Soie de Paris) needs waxing.

4. Outline petals 3 with 2 strands of Knysna Forest no 5 in split stitch. Fill in the petals with long and short stitch using the same thread.

5. Outline petals 2 with split stitch using 2 strands of Camellia no 5. Shade these petals working long and short stitch using 2 strands of Camellia no 5, then 4 and then 3, taking care to achieve a gentle blend when you switch colours. I work on both petals at the same time as this gives me an idea when and where to stop with each colour.

6. Stitch the outer edge of the leaves with split stitch using 2 strands of Knysna Forest no 5. Shade the leaves in long and short? stitch with 2 strands of Knysna Forest no 5, then 4 and then 3.

7. If you have never worked with gold thread before, it might be a good idea to practise a little on a separate piece of fabric. Start your laid work in petals 4

using the T70 Imitation Japanese gold (Jap), working from the outside to the inside. Remember that the Jap is always couched in pairs. Couch the gold threads with 2 strands of well-waxed Camellia no 5. Follow with one check thread no 5. You will working with T70 and check no 5 alternately, so all the gold threads must be plunged at the beginning and at the end. You may start with a loop to cut down on plunging. Do not panic if your edge is not perfect, as it will be covered with the pearl purl. Shade the couching thread from dark to light. Change to a lighter colour every third row. Work until the area is filled.

8. Stitch 4 small sequins onto the calyx to represent the seed. Add a small piece of red-orange rough purl in the centre. Cut the check purl into small beads and fill in seed pod with chip work.

9. Fill in the top half of the calyx with cutwork using the gold and the red-orange rough purl. I stitched three pieces of gold to one piece of red-orange rough purl.

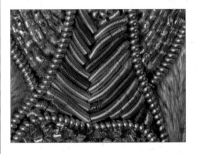

10. Refer to the picture to guide you, and outline the petals, leaves and calyx with no 1 pearl purl.

11. Complete the cutwork on the stem alternating gold and red-orange rough purl. As with the calyx, I used three pieces of gold to one piece of red-orange rough purl.

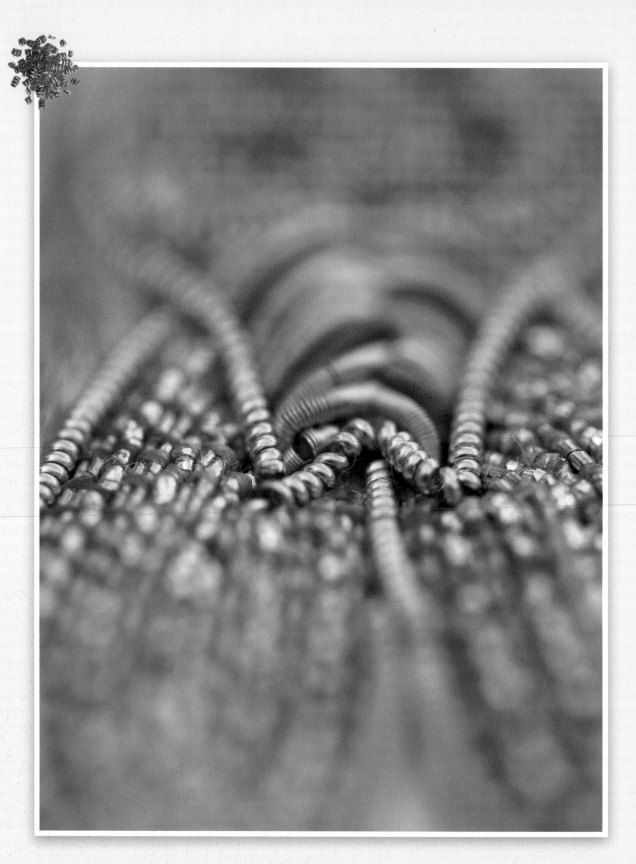

Embroiderers love the opulence of goldwork which has become very popular.

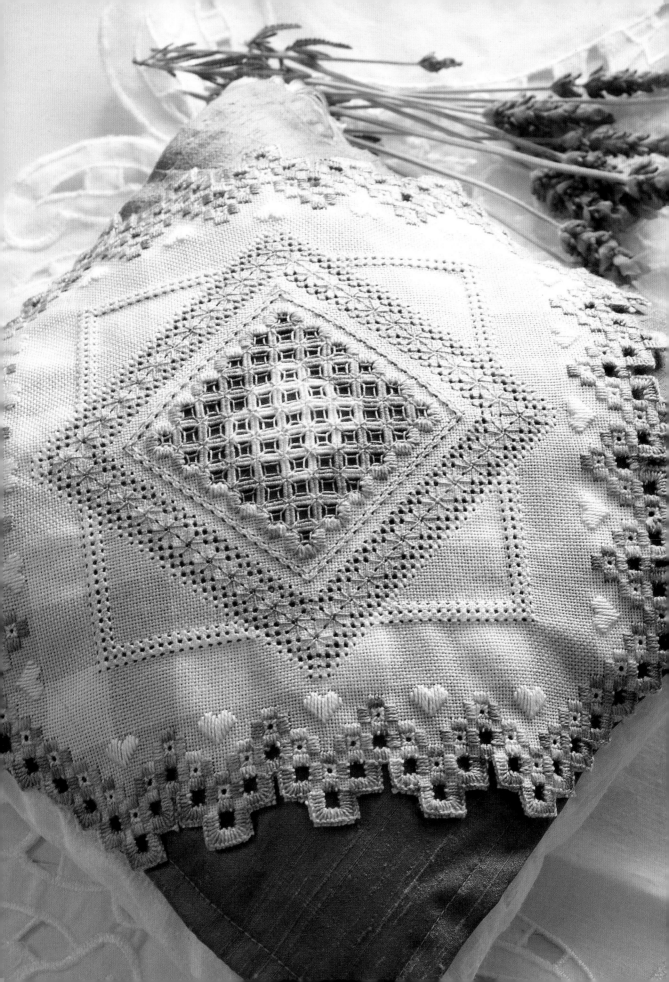

Hardanger

Hardanger embroidery is named after a region in the southwest of Norway. It is a form of counted-thread embroidery and would sometimes include drawn thread embroidery and also some filling stitches. It is believed that the early forms of this embroidery were introduced to Norway by Norwegian traders returning from their travels from eastern Europe and the Middle East. Hardanger embroidery was done on fine linen (50 count evenweave) and designs were fairly simple. In the 17th century it was very popular to decorate household linens and clothing with this form of embroidery.

Traditional hardanger embroidery is worked in white thread on a white background, and is part of a category of embroidery known as whitework. Today, however, there are many more options. Using space-dyed threads and fabrics adds a whole new dimension to this exciting form of embroidery.

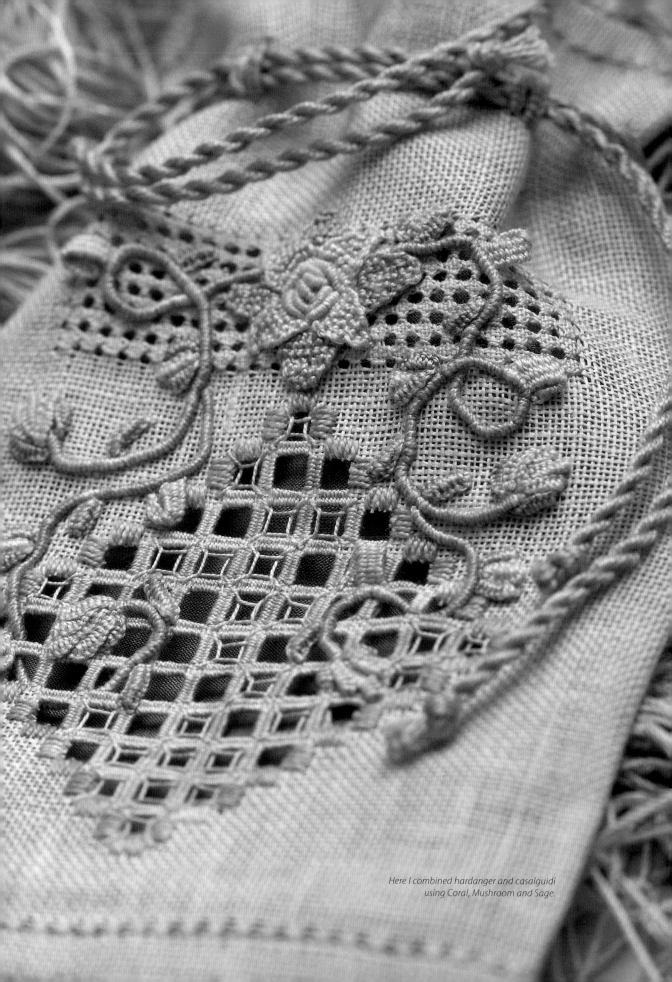

*Here I combined hardanger and casalguidi
using Coral, Mushroom and Sage.*

Basic techniques

As is the case with goldwork, there are several techniques peculiar to this form of embroidery.

KLOSTER BLOCKS

Kloster blocks are probably the best known feature of hardanger embroidery. A kloster block consists of five satin stitches worked over a four-thread square, forming a little block. These blocks are stitched either in rows or diagonally (see page 119). You can use perlé no 5 or no 8. I prefer working with perlé no 8 thread.

A finished kloster block before the cutting of the threads

CUTTING AWAY THREADS

Once you have finished stitching the kloster blocks, threads are cut away to give the embroidery a lacy appearance. I leave the cutting of threads until all further stitching has been done. Always cut in good light and use very sharp, pointed scissors.

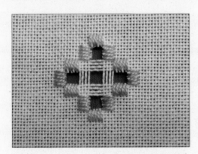

In this example the threads have been cut and removed

Never cut late at night or when you are tired (especially if you have had a glass of wine) as you may spoil all your hard work by cutting into the stitches. Always cut away against a stitched side and be careful not to nip the stitches forming the kloster blocks.

NEEDLEWEAVING

Use a finer thread like perlé cotton no 12, either in the same colour as the kloster blocks or in the colour of the background fabric. If you are using a strong colour for the kloster blocks it is advisable to do the weaving in colour similar to the fabric otherwise the strong colour may become rather overpowering. The weaving must be tight and even. I count the number of weaves going into the first bar and repeat that in the following ones (see woven bars page 119).

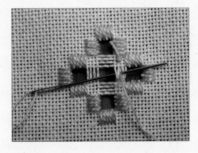

FILLINGS

When the kloster blocks have been cut and woven a variety of fillings can be added for a decorative effect. I have only used the dove's-eye (below) and square-filet filling. For more options, consult a

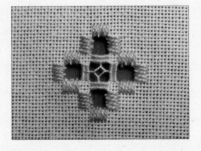

book on hardanger embroidery (see bibliography page 128).

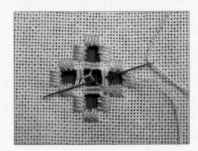

Dove's-eye filling (above) is stitched after three and a half bars have been wrapped. When completed, the fourth bar is done.

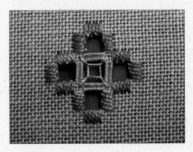

Square-filet filling (see page 119) looks the same as dove's-eye filling (see page 119) but is anchored in the four corners.

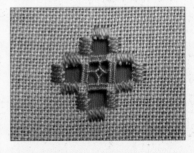

The two samples above also illustrates the different looks achieved when the weaving is done in a colour similar to that of the fabric, and when done in the same strong colour as the kloster blocks.

BUTTONHOLE-STITCH EDGING

This stitch (see page 119) is used to finish off the edge of the design and prepare it for cutting.

Lavender cushion

YOU WILL NEED

> 35 x 35cm 28-count Palermo
(Jobelan) check even-weave
fabric, lavender
> 3 twin packs of Chameleon
Pansies (perlé no 8 and 12)
> Chameleon perlé no 8
Snowy Mountains
> White perlé no 12
> No 26 tapestry needle
> Sharp-pointed scissors
> Small clip-frame
embroidery hoop

Preparing the fabric

Iron the fabric and ensure that the edges are straight; finish the edges to prevent the fabric from fraying. Fold the fabric in half to find the centre and tack a line using a tapestry needle and coloured thread. I used the fabric design to guide me and did my tacking between two check blocks. Do this horizontally and vertically.

Stitching the centre block

1. Count down from the centre of the fabric and work the kloster blocks in the centre of the design using Pansies perlé no 8. Don't cut the threads yet.

2. Add a surround of reversed diagonal faggot stitch using Pansies perlé no 12 over 3 threads. This stitch will give you two rows of stitches simultaneously. In the same thread, work 2 rows of faggot stitch over 3 threads.

3. Add a row of blanket-stitch eyelets stitched over 6 threads, using Pansies no 12 perlé. Work blanket-stitch eyelets as follows: when coming out at the top of a leg, don't go directly into the centre hole as you would for a normal eyelet, but first enter the top of the next leg, then come out of the centre hole with the thread under the needle as in blanket stitch. The legs of the eyelets will fit snugly into the holes made by the faggot stitch.

4. Surround the blanket stitch eyelets with 3 rows of faggot stitch over 3 threads. The first 2 rows are stitched in Pansies no 12 perlé and the last row in white perlé no 12. This completes the centre block.

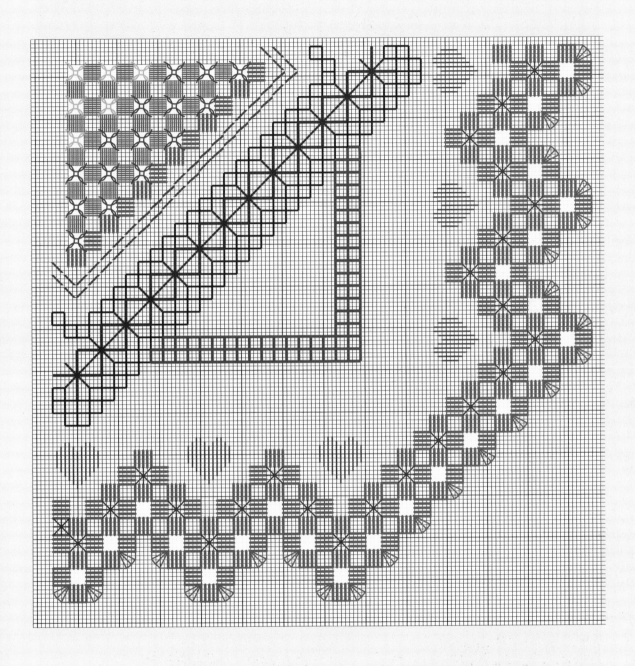

 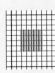

square-eye filling kloster block needle weaving eyelet faggot four-sided stitch buttonhole eyelet satin-stitch heart reversed faggot

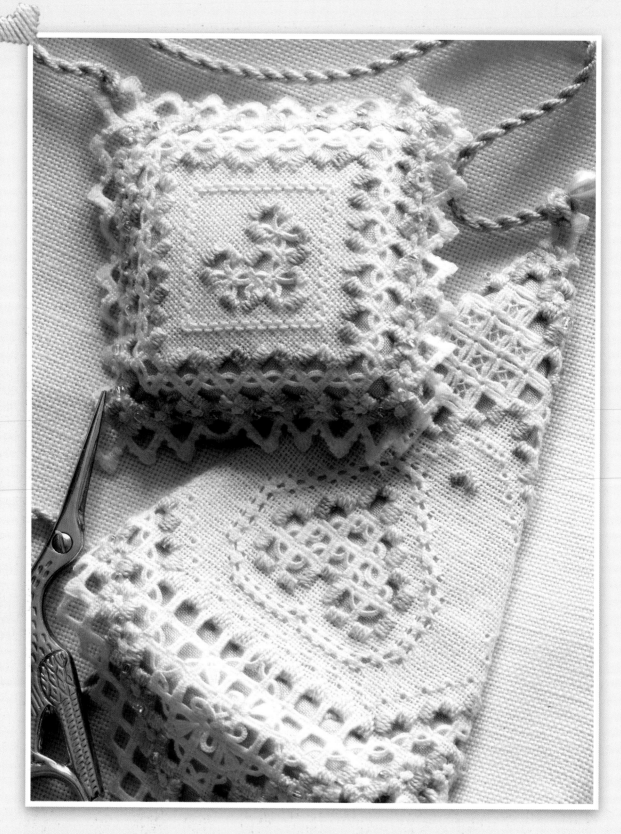

Scissor case and scissor keep designed by Lynn Laver. I stitched it using Chameleon Wild Berry perlé no 8 on 36-count Irish linen.

Second block pattern

Stitch 2 rows of four-sided stitch over 3 threads using white perlé no 12 thread. This will form the second block pattern.

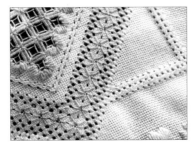

Lacy edge

1. First stitch 2 rows of kloster blocks in Pansies perlé no 8 following the pattern. Finish the edge in buttonhole-stitch edging in the same thread. Do not cut the kloster blocks yet!

2. Thread up with white perlé no 12 and finish by adding the small, square eyelets in the centre of the kloster blocks, then embroider the white satin-stitch hearts using perlé no 8 Snowy Mountain.

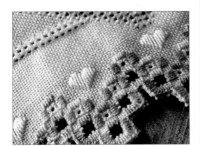

CUTTING THE THREADS

Now the fun part starts! Using a very sharp pointed scissors carefully cut the threads in the centre part of the design. Be very careful not to nip one of the kloster-block threads.

NEEDLEWEAVING

By following the diagram and picture, you can now start weaving first using the perlé no 12 Pansies and then the perlé no 12 white (see photo). Complete by adding the square-filet filling in perlé no 12 Pansies and white.

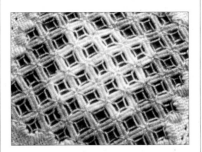

FINAL CUTTING

Carefully cut all the holes in the lacy edge. Complete by cutting around your design.

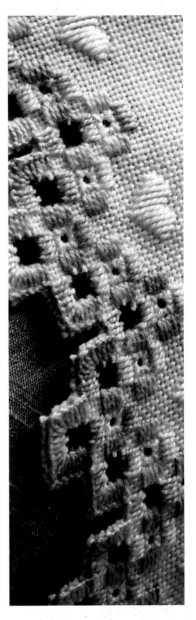

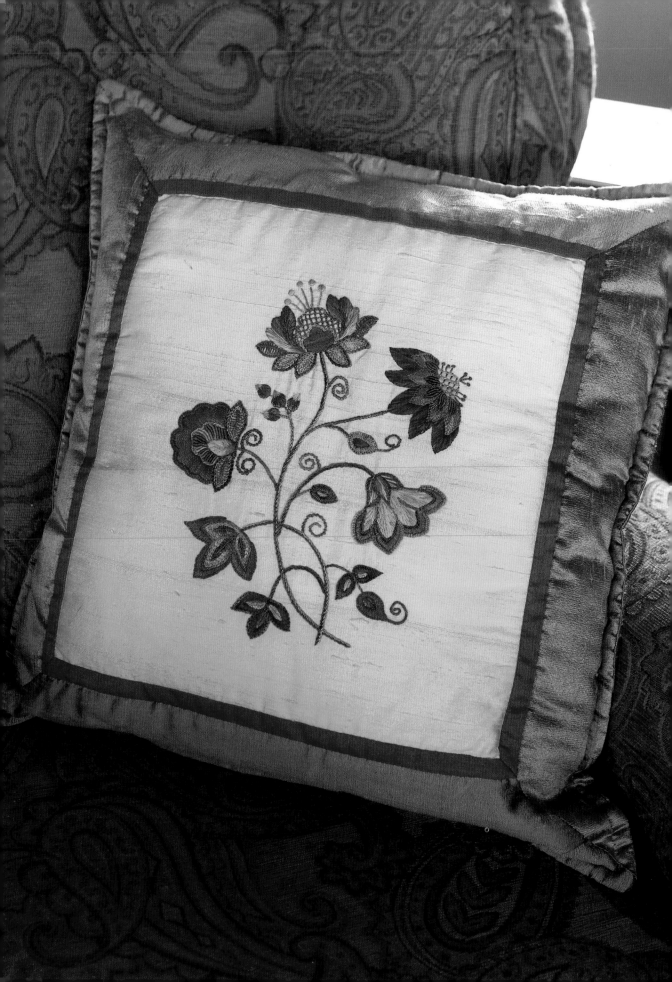

Jacobean style

The terms Jacobean and Crewel embroidery are often used synonymously and this can be very confusing. However, the difference between the two terms is very easy to explain. Crewel embroidery refers to any embroidery done using crewel wool – a two-ply worsted wool used for surface stitching The most famous example would probably be the famous Bayeux Tapestry worked in the 11th century. The term Jacobean embroidery refers more to a style of embroidery. With the establishment of the East India Company in the 1600s England imported vast quantities of painted cottons from India.

These cottons featured designs like the Tree of Life, exotic flowers, veined leaves and various birds and animals. As the designs were very popular, they were copied and used in the embroidery of the time. This style of embroidery flourished under the reign of King James 1 from whose full Latin name, Jacobus Brittaniae Rex, the term Jacobean was derived. Beautiful pieces of embroidery were stitched in the Jacobean style using crewel wool.

Floral delight

Level of proficiency

✳ ✳ ✳

YOU WILL NEED

› *30 x 30cm crème Dupion silk or any other fabric of your choice*
› *30 x 30cm backing fabric (I use a light fabric such as muslin)*
Chameleon stranded cotton
› *Baobab*
› *Gold Rush*
› *Pinotage*
› *Vine Leaves*
Chameleon perlé no 8
› *Baobab*
› *Gold Rush*
› *Green Olives*
› *Moss*
› *Pinotage*
› *Vine Leaves*
Needles
› *No 3 Crewel needle*
› *No 24 Tapestry needle*

› *Embroidery hoop big enough to take the whole design*
› *Small sharp-pointed embroidery scissors*

For the designed I embroidered for the book I have obviously chosen to use space-dyed threads. This gives a wonderful dimension to this style of embroidery. I chose to use my embroidered design as a cushion front. It will, however, also look beautiful on a bag or even as a book cover.

Colour variation

Chameleon Scottish
 Heather (Baobab)
Chameleon Sea Sand
 (Gold Rush)
Chameleon Cloudy Skies
 (Green Olives)
Chameleon Scottish
 Highlands (Fern)
Chameleon Winter
 Dawn (Pinotage)
Chameleon Sea Mist
 (Vine Leaves)

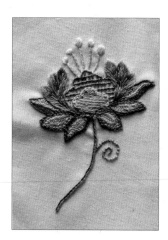

For this sample I have chosen softer, more subdued colours and the result is quite pleasing.

Getting started

First trace the design on page 121 onto tracing paper using a black felt-tip pen. This will help you to see the design better when drawing it onto your fabric. Tape the design to a light box or onto a window pane and tape your fabric over the design using masking tape. Draw the design onto the fabric with a sharp, soft pencil. Never use a ball point pen! You do not want a beautiful piece of stitching spoilt by ink running. I prefer not to use a water-soluble pen as the lines tend to be to thick, making it difficult to stitch small areas. The ink also tends to disappear in time as the moisture level in the air increases.

Place over the backing fabric and put both pieces of fabric into your embroidery hoop. Tighten the hoop, making sure that the fabric is nice and taut. Keep checking that it stays like that whenever you are stitching.

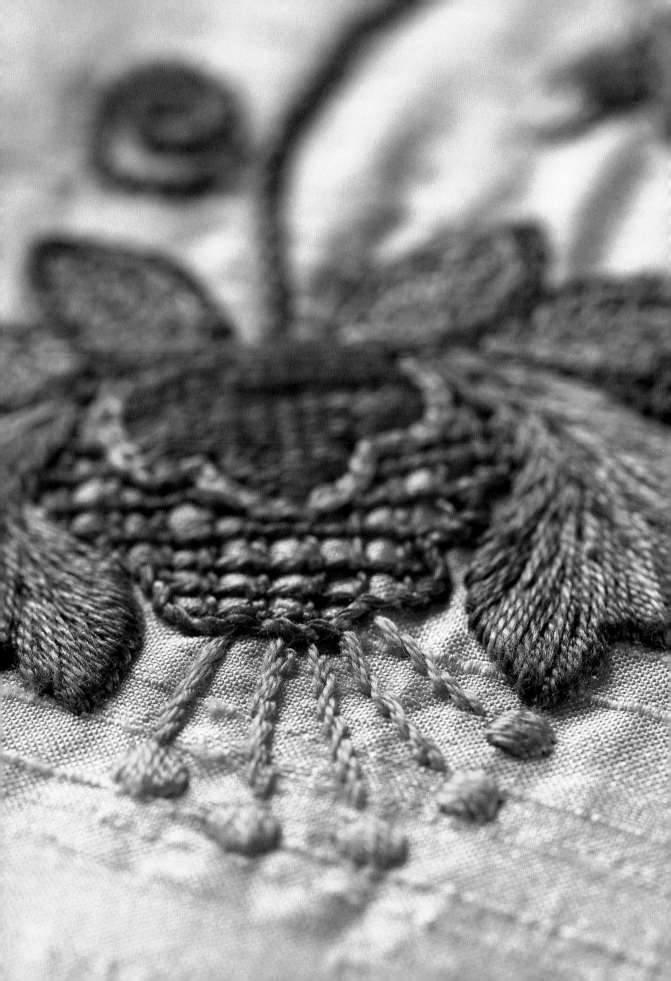

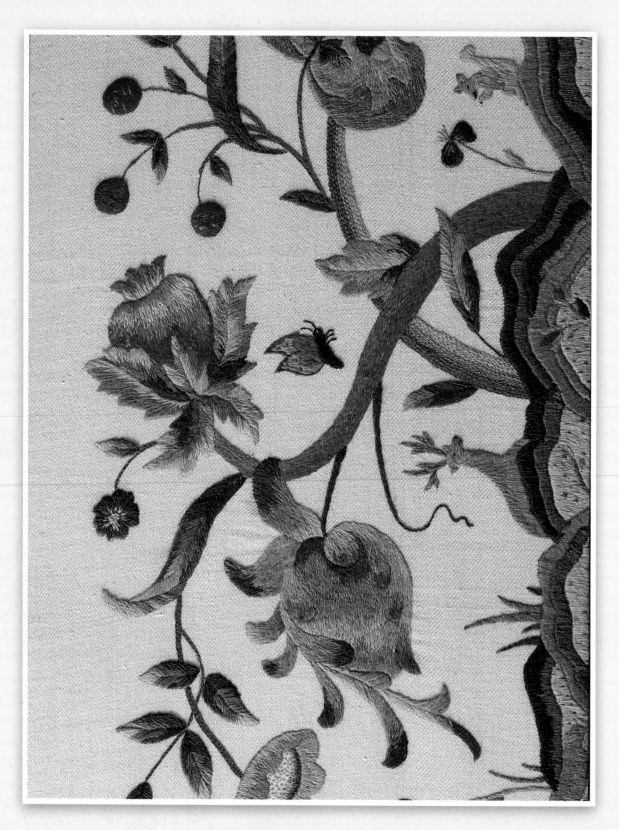

Traditional crewel work in the Jacobean style stitched with Appleton wools by my mother Sylvia du Plessis.

Flower 1

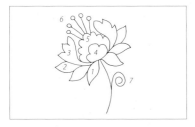

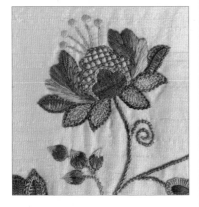

1. Outline the four bottom leaves with a row of chain stitch using Green Olives perlé in the crewel needle. Add another row of chain stitch in Moss perlé. Fill in the remaining area with fly stitch in Gold Rush perlé.

2. Outline two side leaves with stem stitch using Green Olives perlé. Fill the centre with Van dyke stitch in Pinotage perlé. (Use the crewel needle for the first Van dyke stitch, then change to the tapestry needle. It will be easier to take the needle underneath the first stitch using the tapestry needle.)

3. Cut several lengths of Vine Leaves stranded cotton with exactly the same colour sequence, making sure that you have equal amounts of yellow, red and green in each strand. Separate the lengths into strings of 2 strands each. Thread up the crewel needle with 2 strands and outline the stitched area in split stitch. Start by outlining each leaf shape. Thread your crewel needle so that the yellow part of the thread is at the bottom. Remember to use all the threads like this. Now carefully fill each section of the leaf in long and short stitch using the yellow part of the thread for the first section. Continue using the red part of the thread for the second section and the green for the third section of the leaf. If you run out of thread but you have not finished a section, simply go on to the next section and just start again beginning with the yellow. Pad these areas well.

4. Outline this area in chain stitch using Gold Rush perlé. Fill the rest of the area in raised outline stitch using Pinotage perlé. Once you have stitched down the bars, change to the tapestry needle for whipping the bars. Make sure that this area is closely packed (see page 48 – padded raised-stem band).

5. Outline this area in whipped stem stitch, first using Vine Leaves perlé and then whip with Gold Rush perlé. Fill the inner area with squared filling-stitch using Vine Leaves perlé, tying down with one diagonal stitch.

6. Stamens are stitched in stem stitch using Gold Rush perlé and finished with a small padded satin stitch circle using 2 strands of Gold Rush stranded cotton.

7. Work the curlicue in coral stitch using Baobab perlé.

Flower 2

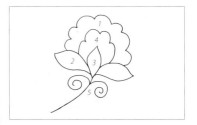

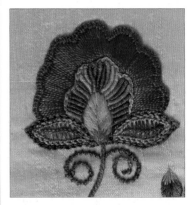

1. Fill the area with buttonhole stitch using Pinotage perlé. As the area has curves, you will have several open spaces between the stitches. Simply fill in these areas with straight stitches once you've completed the buttonhole. Do another row of buttonhole stitches on the outer edge, taking care not to pierce the fabric. This will result in a beautiful frilled edge.

2. Outline both leaves in chain stitch using Green Olives perlé. Add another row of chain stitch in Moss perlé. Fill the centre with Van dyke stitch using Vine Leaves perlé.

3. Outline with split stitch using 2 strands of Gold Rush. Continue to fill the area with long and short stitch. Add a few straight stitches using 2 strands of Baobab at the base of this shape.

4. Outline with chain stitch using Gold Rush perlé. Fill in the rest of the area with

bullion knots using 2 strands of Vine Leaves stranded cotton.

5. The curlicue is stitched in coral stitch using Green Olives perlé, and the stem is stitched in rope stitch using Baobab perlé.

Flower 3

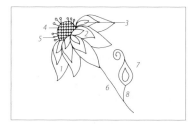

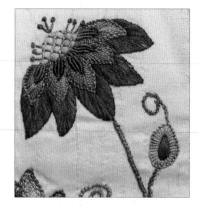

1. Outline five leaves with split stitch using 2 strands of Pinotage stranded cotton and then fill in with long and short stitch.

2. Fill with buttonhole stitch using Vine Leaves perlé, adding extra straight stitches in any open areas. You will find that the stitch in the point will not lie flat. Just tie it down with one stitch.

3. Fill these areas with three bullion stitches using 2 strands of Green Olives stranded cotton. First stitch a long bullion knot in the middle and then add two smaller ones on either side to form an oval shape.

4. Outline in split stitch using 2 strands of Gold Rush stranded cotton. Now fill the area with padded satin stitch. Add a trellis filling on top of the padded satin stitch using Vine Leaves perlé and tie down with Gold rush perlé.

5. Use Baobab perlé for the stamens and the stem. The stamens are worked with one straight stitch ending in a French knot, and the stem is worked in rope stitch.

6. Work the small stem with two rows of stem stitch in Green Olives and Moss perlé.

7. Buttonhole the outer edge of the leaf with Moss perlé. Fill the centre in long and short stitch using 2 strands of Pinotage stranded cotton.

8. Finish with a curlicue in stem stitch using Green Olives perlé.

Flower 4

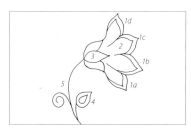

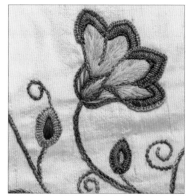

1. Fill the area with buttonhole stitch using Vine Leaves perlé following sequence 1a–1d. So you first complete the leaves at the back ending with 1d in front. Add another row of buttonhole stitch on the edge following the same sequence, taking care not to pierce the fabric.

2. Stitch a line of stem stitch in Green Olives perlé at the base of the buttonhole stitching of the previous area. Using Vine Leaves perlé and stem stitch add the lines that separate the four petals in this area. Now fill in the four leaf areas with long and short stitch using 2 strands of Gold Rush stranded cotton.

3. Outline the three base leaves in stem stitch using Moss perlé. Add another row of stem stitch using Vine Leaves perlé. Fill in the rest of the area with long and short stitch using 2 strands of Vine Leaves stranded cotton.

4. Work the outer edge of the leaf in buttonhole using Moss perlé. Fill the centre with Van dyke stitch using Gold Rush perlé.

5. Work the stems in stem stitch. For the small stem use Moss perlé; for the large stem wok one row in Moss and one in Baobab perlé. Stay with Baobab perlé and finish off by stitching the curlicue in coral stitch.

Leaf 5

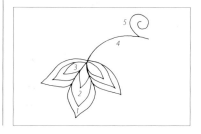

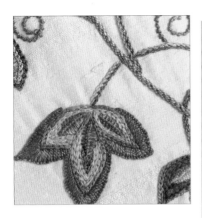

1. Fill the outer areas with buttonhole stitch using Pinotage perlé. Use straight stitches to fill any open areas.

2. Work one row of chain stitch in Baobab perlé around the outer edge and then fill in with more rows of chain stitch using Gold Rush perlé.

3. Work the inner leaves with Van Dyke stitch using Green Olives perlé.

4. For the stem, use stem stitch working one row in Green Olives and one in Moss perlé.

5. Stitch the curlicue in coral stitch using Baobab perlé.

Leaf 6

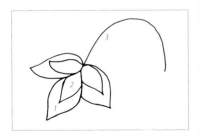

1. Stitch one row of chain stitch along the outer edge of each leaf using Green Olives perlé. Fill the rest of the area with rows of chain stitch using 2 strands of Pinotage stranded cotton.

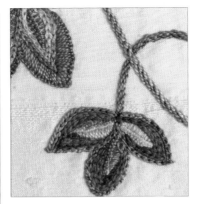

2. Fill the remaining area of the centre leaf with Van Dyke stitch using Vine Leaves perlé. Fill centres of the side leaves with Van Dyke stitch using Gold Rush perlé.

3. For the stem, use stem stitch working one row in Green Olives and one in Baobab perlé.

Leaf 7

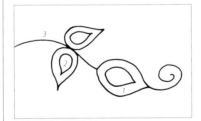

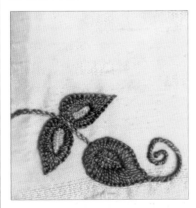

1. Buttonhole the outer edge of the top leaf using Pinotage perlé and use the same thread to work the curlicue in stem stitch. Fill the centre with Van dyke stitch using Green Olives perlé.

2. Buttonhole the outer edge of the side leaves using Green Olives perlé and fill the centres with Van Dyke stitch using Gold Rush perlé.

3. The stem is worked in stem stitch using Baobab perlé.

Buds 8 and long stem

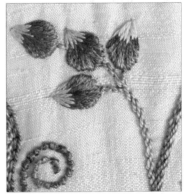

1. Work the buds in long and short stitch in Green Olives stranded cotton (2 strands) for the lower third and Pinotage for each middle section, then use Gold Rush perlé for the tips.

2. The stem is stitched in stem stitch using Moss perlé.

3. The long stem running up to flower 1 is worked in two rows of stem stitch, Green Olives perlé and Moss.

Ribbon embroidery

Silk-ribbon embroidery was first used to adorn the vestments of the clergy. During the Industrial Revolution French dressmakers used it to create unique gowns for the rich and the famous who refused to wear mass-produced garments. The technique was ideal for embellishing garments for demanding clients who changed gowns up to five times a day, since it not only achieved exquisite results, it achieved them fairly quickly. The Australians started using silk-ribbon embroidery extensively in their stitch craft in the 1980s, resulting in a resurgence in its popularity. Today it is as popular as ever, with an abundance of exquisite silk and organza ribbons available in every imaginable colour. Hand-painted silk and organza ribbon combine particularly well with space-dyed thread, as they yield the same subtle shades and interesting colour variation. This simple design of a flowering onion (*Allium oleracium*) makes a lovely framed piece, but can also add a special touch to a scrapbook page or a special card. Embroider on a cotton background, stretch and mount before gluing to the page or card. Or embroider directly on a handbag or jersey or the background of a trinket box.

Design painted by Klara Marie den Heijer and sitched by Di van Niekerk

Botanical beauty

Level of proficiency

✳ ✳

YOU WILL NEED

> *Design printed on cloth (or transfer line drawing on page 120)*
> **Chameleon threads**
> *(use one strand unless otherwise specified)*
> *Stranded cotton – Baobab, Marigold*
> *Stranded silk – Charcoal, Kiwi, Forest Shade, Winelands*
> **Di van Niekerk's pure silk ribbons**
> *1 packet 2mm Sabie Shade (no 126)*
> *1 packet each 4mm Antique Brown (no 21), Hyacinth (no 64)*
> *2 packets 13mm Dark Pine (no 25)*
> *1 packet 13mm Antique Brown (no 21)*
> **Needles**
> *No 8 or 9 crewel for two strands of thread, no 9 or 10 crewel for one strand of thread*
> *No 18 chenille for 7 and 13mm ribbon, no 20 to 22 chenille for 4mm and no 22 to 24 for 2mm silk ribbon*
> *6 pale brown, melon shaped wooden, glass or ceramic beads*
> *20 cm thick green, grey or light brown wool*
> *14 or 16 inch quilting hoop*
> *Backing cloth same size as printed cloth (fine white or off-white cotton voile or polycotton)*
> *Second backing cloth as above for trapunto (optional)*
> *Small sharp-pointed embroidery scissors*

TIP: Printed design available from www.chameleonthreads.co.za or copy and transfer the image to white or off-white cotton fabric large enough to fit snugly in a 14 or 16 inch quilting hoop.

Preparing the design

Centre the printed design on the backing cloth and insert in a 14 or 16 inch quilting hoop. Pull the layers taut and tighten the hoop. Roll up the four corners and pin or tack out of the way so they don't hinder you while you work.

Work the bulb

1. Outline the bulb in 2 strands of Baobab thread using back or stem stitch and fill in the dark brown detail on the bulb in the same stitch. Change to 1 strand of Charcoal thread and fill in the black lines above the roots in stem stitch. Change to 4mm silk ribbon no 21 and form the roots in twisted straight stitch. Use 1 strand of Baobab thread and coax the ribbon into a curve using tiny stab stitches.

2. Use 2 strands of Kiwi thread and fill in the green stem section of the bulb in long and short stitch or stem-stitch filling. Change to 2 strands of Baobab thread and fill in the dark brown top

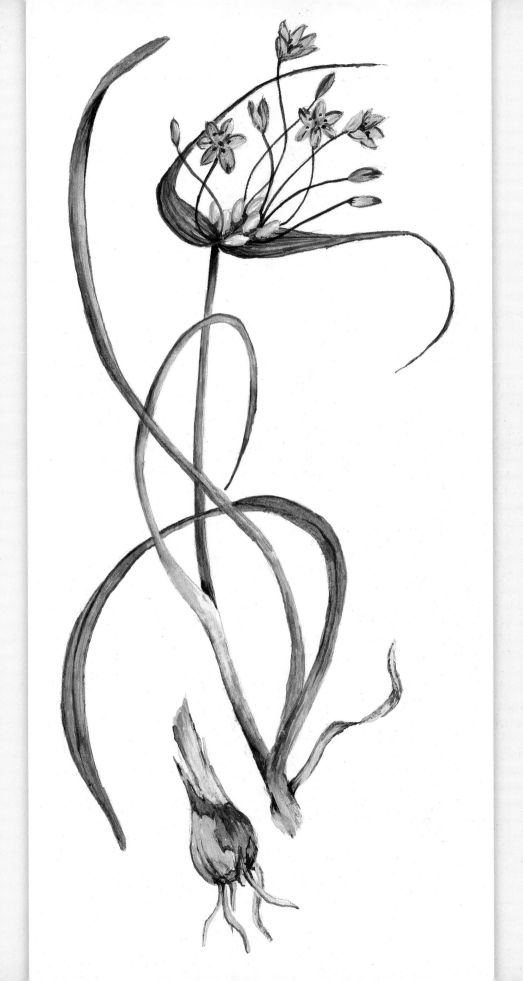

section in the same way. Complete the light brown section of the bulb using 2 strands of Marigold thread and the same stitch. Go back to fill in any gaps in straight stitch for a smooth finish.

Work the stem

1. Make the long upright stem. Secure the wool at the base of the plant with small stab stitches in Kiwi thread. Let the wool lie on top of the fabric. Cut a 45cm length of 13mm ribbon no 25 and thread a no 18 chenille needle. Insert the needle from the back close to the wool at the base of the stem. Wrap the ribbon around the wool to cover it. Allow the stem to curve on top of the work and insert the needle to the back at the brown bracts.

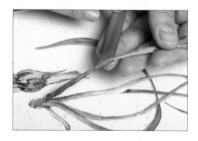

2. Use the Kiwi thread and tiny stab stitches 1 to 2cm apart along the edges of the stem to secure it in place. Use a gentle tension to avoid flattening the stem. Cut off the excess wool.

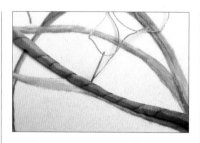

Form the leaves

1. Thread up with the same 13mm no 25 ribbon, bring the needle up at the base of stem and form the long leaf curving to the left of the blue flowers. Use a twisted straight stitch (see page 000), twisting the ribbon loosely, several times to form a narrower leaf. Insert the needle to the back. Check that the twisted ribbon fits well on the design, pull the leaf into shape and end off.

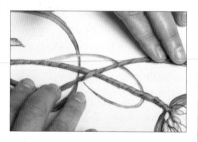

2. Use the Kiwi thread and tiny stab stitches as for the stem to secure the ribbon in place. Come up along the edge of the leaf on the fabric, catch the edge of the curved ribbon and insert the needle close to where the thread emerged.

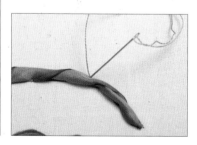

3. Start at the base again and form the second curved leaf below the blue flowers. Use the Kiwi thread to secure the flat section of the leaf along the base of the stem with tiny stab stitches. Then twist the ribbon before inserting the needle to the back again. Ensure there is enough ribbon to cover the curved leaf and end off as before. Use the same Kiwi thread to secure the curved and twisted ribbon in place

4. Repeat for the third leaf. Start at the base of the stem and use tiny stab stitches to secure the flat section in place along the edges. Twist the ribbon to form a curve before inserting it to the back again.

5. The small brown leaf at the base is made the same way using 4mm silk ribbon no 21.

Add the bracts

1. Thread up with 13mm silk ribbon no 21, come alongside the stem and make a twisted straight stitch as before. Use the Baobab thread to secure the thick, flat section in place with tiny stab stitches, twist the ribbon and insert the needle to the back. Use the same brown thread to secure the twisted ribbon in place with tiny stab stitches.

Couch (see page 119) the ribbon for a fine, rounded point. Come up along the left edge, stitch over the ribbon, and insert the needle to the back close to where the thread emerged.

2. Repeat the second bract, this time stitching over the raw ends of the stem.

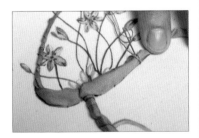

Stems and flowers

1. Thread up with 2mm silk ribbon no 126. Start just above the stem and work on top of the brown leaves. Form the fine green pedicels of the blue flowers in twisted straight stitch. Couch in place with Forest Shade thread. Use the green ribbon or thread and add a few French knots (2 or 3 wraps) between the brown beads for shadows.

2. Change to Baobab thread and attach 7 brown beads on top of the brown leaves. Use 4 to 5 anchoring stitches for each bead.

3. Change to the 4mm silk ribbon no 64. Form the blue petals in ribbon stitch (see page 119) or detached chain (see page 119). Use Winelands thread and make French knots (2 wraps) on top of the blue flowers to form the stamens.

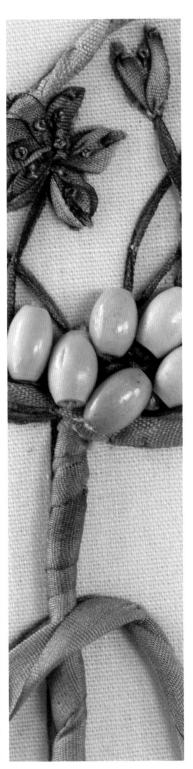

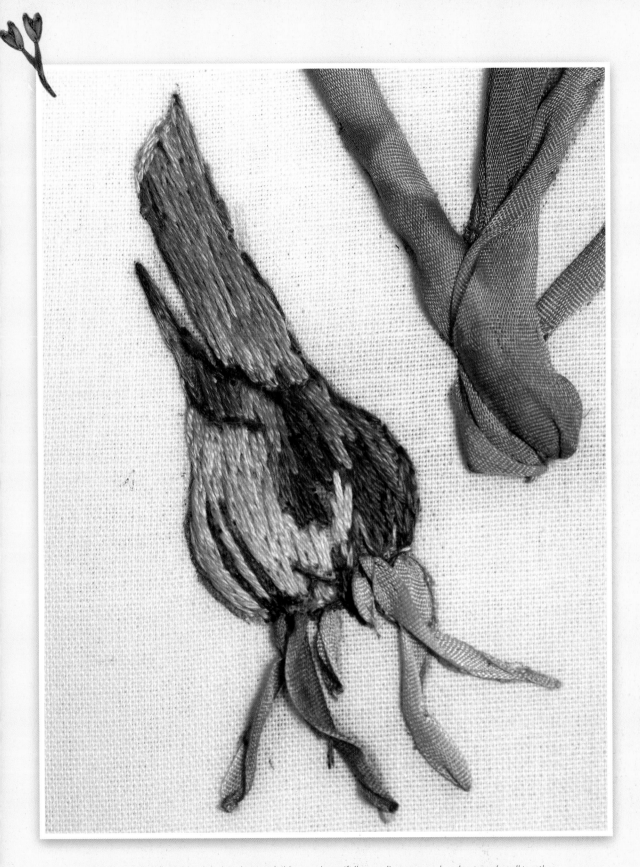

The colours of the space-dyed threads and the hand-painted ribbon are beautifully complimentary and work extremely well together.

Stumpwork

Raised embroidery of the 16th century gradually became more elaborate and by the 17th century was known as stumpwork. This form of embroidery reached its peak during 1650 to 1680 and was mostly stitched by young girls as part of their education in needlework. Many of the pieces were fitted on small caskets or mirror frames and can still be seen in museums today. The designs were pictorial and always included people wearing contemporary Stuart costume or even biblical figures. The scale was often wrong and open spaces were filled with flowers, animals, birds and insects.

This beautiful piece was designed and stitched by Elsa le Roux

The designs were drawn onto cream satin with ink. Some embroidery was then stitched directly onto the background and some was stitched separately in the form of small slips. A variety of threads including metal threads, wool, cords, braids, pearls, beads, spangles, feathers and even jewels was used. The stitch most widely used was detached buttonhole in its many forms. Knotted stitches, long and short stitch, satin stitch and laid work was also used extensively. Fortunately, many well-preserved pieces can still be seen in museums today.

Daisies galore!

Level of proficiency

✳ ✳ ✳

YOU WILL NEED

Fabric
› *50 x 50cm closely woven cotton or linen – navy (background fabric)*
› *50 x 50cm calico (backing)*
› *20 x 20 cm dark green fabric (leaves)*
› *30 x 50cm white cotton (flower petals)*
› *Small piece of green felt (padding for the bud)*

Chameleon Soie de Paris
› *1 x Petal Beige*
› *3 x Spilt Milk*
› *2 x Forest Shade*
› *2 x Green Olives*
› *1 x Nasturtiums*
› *1 x Baobab*

Chameleon Soie d'Alger
› *3 x Spilt Milk*

Needles
› *No 8 and 10 crewel*
› *No 18 chenille*

› *White and light green sewing thread*
› *8 lengths of florist's wire*
› *Small sharp-pointed scissors*
› *10 and 30cm embroidery hoops*
› *12 x 25cm tissue paper*
› *Thin white card*
› *Sharp pencil*
› *Craft knife*
› *Black permanent marker*
› *Overlocker tweezers*
› *Pins*

Transfer design onto background fabric

1. Fold the background fabric into quarters to find the centre and mark this point with a tacking stitch or pin. Position the background fabric over the calico backing, aligning the straight grain of the two fabrics and place in the large embroidery hoop, pulling both fabrics nice and taut.

2. Trace the design on page 125 onto tissue paper and pin the tissue-paper tracing to the fabric in the hoop, using the marked centre as a guide to ensure good placement. Work small running stitches along the design lines in green sewing thread for the stems and leaves, and white sewing thread for the flower petals, taking care to stitch through all the layers.

3. Gently score the tissue paper with the back of a needle and remove. The running stitches on the stems and the surface embroidered petals will be covered by the embroidery stitches. The rest of the running stitches will be removed after the detached elements have been placed.

Work the stems

1. Thread up a no 8 crewel needle with 2 strands of *Soie de Paris* Forest Shade and pad all the stems with 2 rows of closely worked chain stitch.

2. Cover with rows of closely worked stem stitch using 1 strand of *Soie de Paris* Green Olives. Do not pull the stitches too tight, as it will flatten the padding stitches. To achieve a smooth surface work the first row, turn and work the next row in the opposite direction. Repeat until the padding is covered.

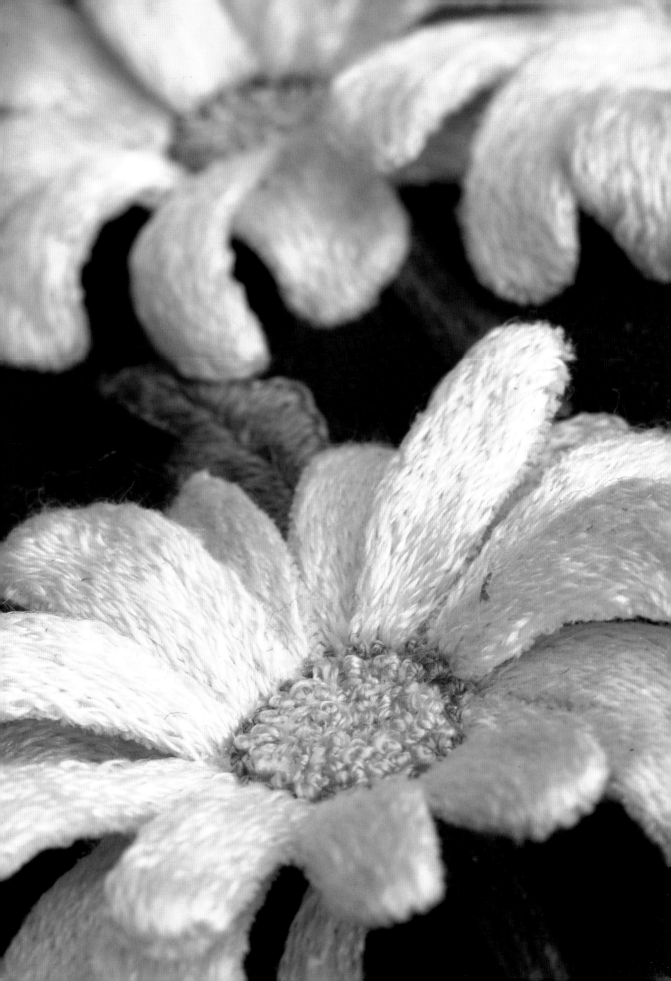

Embroider the leaves

There are 11 leaves, all of which are detached but worked without florist wire. They will not fit into the hoop all at once, so move fabric in the hoop as necessary while you embroider the leaves. Use a no 10 crewel needle throughout, starting with 2 running stitches and a back stitch and ending off with a few running stitches. The left and right sides of the leaves on the design are shaded differently. Imagine the light is falling onto the design from the left. When shading the leaves on the right side of the design, work the lightest shade on the left of each leaf and the darkest shade from the central vein to the right. Do the opposite on the leaves on the left side of the design.

1. Trace the leaf shapes on page 122 onto thin white card with a black marker and cut out with a craft knife. Place the dark green fabric in the 10 cm hoop and trace the leaf outlines onto the fabric with a sharp pencil, using the card as a template. Draw in the central vein and write the symbol of each leaf (a to k) on the fabric next to the leaf (not inside as this will be covered with stitches).

2. Thread up with 1 strand Soie de Paris Green Olives and work blanket stitch on one half of the leaf (dark side). Continue on the other half with 1 strand of *Soie de Paris* Forest Shade (light side). Do not stitch the central vein at this stage.

3. Using the same thread, pad each half of the leaf in the relevant green, leaving 2 mm on either side of the vein without padding.

4. Work one row of long and short stitch in 1 strand of Green Olives in the half outlined with Green Olives, covering the padding completely. Add a second row using 1 strand of Forest Shade. Work all the stitches at an angle to the vein. When working the second row, pierce the stitches of the first row. Work the long and short stitches right up to the inner edge of the blanket stitches – only the loops of the blanket stitch must show. Repeat on the opposite side, first using Forest Shade and then Green Olives. Ensure that the stitches meet on the central vein.

5. Work stem stitch along the central vein using 1 strand of Green Olives. Complete the other leaves bearing in mind the shading. Do not cut out the leaves at this stage.

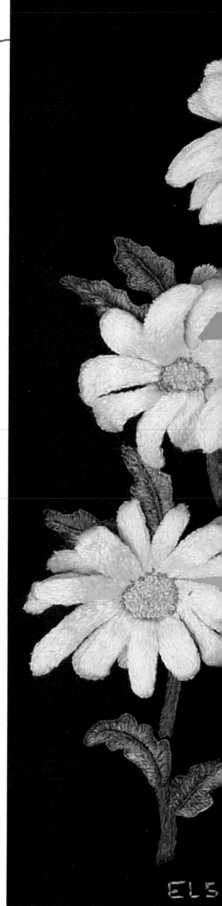

EL5

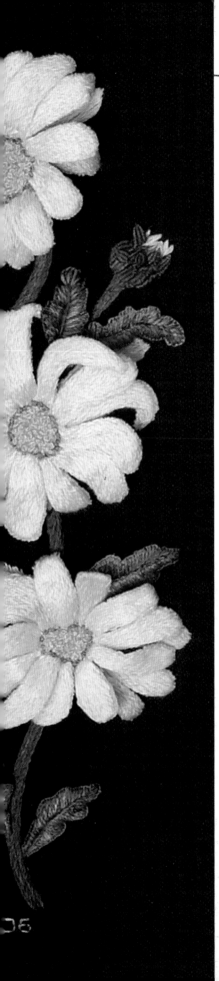

Make the bud

1. Using the bud outline on the main design as a template, cut two buds from green felt, one the actual size and the other slightly smaller. Place in position on the main design, first the smaller with the other on top, and tack down with sewing thread. Thread up with 1 strand of *Soie de Paris* Forest Shade and cover the felt in split stitch.

2. Using 1 strand of *Soie de Paris* Green Olives make seven woven picots of different lengths in two layers (follow instructions for Casalguidi on page 51). Ensure that the base of the picots covers the felt at the lower end of the bud. Secure the tips of the picots with the same thread to create a pleasing effect.

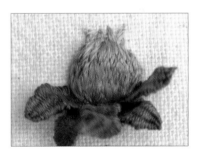

3. Thread up with *Soie d'Alger* Spilt Milk and work a few straight stitches at the top of the bud to form white petals showing.

NOTE: that some steps were done in the colour variation (see page 113).

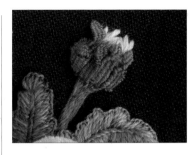

Work the petals

Use a no 10 crewel needle throughout. The petals (pages 122-3) are worked in three ways, namely surface embroidery straight onto the background (B), detached without wire (L), and detached with wire (S). The detached petals are embroidered on the white cotton. Follow the guide for placement, method and colours. X: *Soie de Paris* Petal Beige (dark); Y: *Soie d'Alger* Spilt Milk (medium); Z: *Soie de Paris* Spilt Milk (light).

For each flower, trace and work the petals with and without wire separately, and number and mark (method, thread colour) each petal on the white cotton outside the stitch area. When transferring the petals, be sure to keep each flower's petals together.

When doing the detached flowers, do not stitch or couch the wire further than the solid line at the base of the petal. This 3mm fabric extension is used to stabilize the petals.

The florist's wire is attached to the back of each petal to give a smooth edge. Keep all the loose wire ends in

the same direction and cover with masking tape to prevent the threads catching on them. Detached elements are only cut out once all the embroidery is done. Cut out detached elements one at a time and attach before cutting out the next.

SURFACE PETALS

Work the petals marked surface embroidery (B) on the background fabric in split stitch using 1 strand of Soie de Paris Petal Beige (X). Fill the petals working in rows closely packed together. Work up and down to create a lovely velvety look. No padding is used for these petals.

Flower 1: petals 1, 8, 15, 17
Flower 2: petals 1, 5, 11, 16
Flower 3: petals 1.4
Flower 4: petals 1, 6
Flower 5: petals 4, 11

DETACHED PETALS WITHOUT WIRE

1. Start with flower 1. Place white cotton fabric in the 10cm embroidery hoop, turn over, place over the petal template and trace the petal outlines using a sharp, soft pencil. Number and mark each petal on the fabric outside the stitch area. Take the fabric out of the hoop and turn right side up. If the embroidery is done on the wrong side of the fabric, the petals will not fit the design. Pin the extra white fabric out of the way.

2. Thread up with 1 strand of the thread colour indicated (Y or Z) and outline a petal in blanket stitch (stitch length 2-3mm). Using the same thread, fill the petal with split stitch rows (stitch length about 4mm, but on the edges no longer than 3mm). Work the rows closely together, following the stitch direction indicated on the template. Take the split stitches up to the inner edge of the

blanket stitch so that only the loops of the blanket stitch are visible.

3. Repeat for the other flowers and petals as indicated:
Flower I: Petals 2, 3, 4, 5, 7, 10, 13, 14
Flower 2: Petals 2, 3, 7, 9, 10, 13, 14
Flower 3: Petals 8, 9, 12
Flower 4: Petals 2, 4, 7, 9, 10, 11, 14, 15, 17
Flower 5: Petals 1, 2, 5, 7, 8, 13, 14, 16, 18

4. When stitching petal 7 in flower 2, use Petal Beige for the underside of the tip and change stitch direction as indicated. Do not cut out the petals at this stage.

DETACHED PETALS WITH WIRE

1. Trace the petals onto the white fabric as you did for the detached petals without wire. With the fabric still wrong side up in the hoop, retrace the petal outlines on this side of the fabric, as the lines will be visible through the fabric.

2. Attach the florist's wire to the back of the petals for a softer look. Thread up

with 1 strand Soie de Paris Split Milk and, starting from the base, couch the wire along the outline of the petals, leaving 10mm wire tails at both ends. Secure the wire tails with masking tape.

3. Take the fabric out of the hoop and turn right-side up before tightening the hoop again. Thread up with 1 strand of Soie de Paris Spilt Milk and outline the petals in closely worked blanket stitch, making sure that the wire is enclosed.
Flower 1: Petals 6, 9, 11, 12, 16, 18
Flower 2: Petals 4, 6, 8, 12, 15
Flower 3: Petals 2, 3, 5, 6, 7, 10, 11, 13
Flower 4: Petals 3, 5, 8, 12, 13, 16
Flower 5: Petals 3, 6, 9, 10, 12, 15, 17, 19

4. Fill the petals with split stitch as you did the detached petals without wire using I strand of Soie de Paris Spilt Milk. Do not cut the petals out at this stage.

Attach the leaves

1. Using very sharp embroidery scissors carefully cut out leaf a close to the blanket stitch edge. Thread up with 1 strand of Soie de Paris Green Olives and use tiny stab stitches to attach the leaf to the background. Attach the leaf at its base, then secure the tip and add a few stitches on the edges. Try to create a three-dimensional effect – don't stitch down the entire leaf.

2. Attach the remaining leaves in the same way – one by one to ensure that

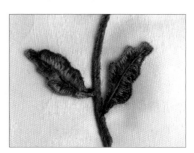

the leaves are placed in the correct position.

Attach the petals

Use the main design as a guide when the petals are placed. To get the best effect, pin down the petals of each flower and make any desired changes. Some of the petals overlap on one side, while some overlap on both sides. In most, but not all instances, the petals without wire are at the back, overlapping each other on one side, while the petals with wire are positioned on top.

1. Using very sharp embroidery scissors cut out the first detached petal for flower 1, as close as possible to the blanket stitch edge. Leave the unstitched 3mm fabric extension at the base intact. Pin the petal in position placing the fabric extension in the centre of the flower. Each petal is cut out and pinned in position individually. If the positioning is pleasing, stitch down the petals with 1 strand of Soie d'Alger Spilt Milk, leaving the fabric extension folded to the front.

2. Repeat with the wired-edged petals. Take the wire tails to the back of the work, using the eye of a no 18 chenille needle to punch a large enough hole. Bend the wire at the back of the work underneath each petal and over-sew it securely for 5 mm using 1 strand of Soie d' Alger Spilt Milk. Cut off any remaining wire.

3. Using the same thread, catch the tips of the petals with stab stitches. Use tiny stab stitches to further secure the petals where necessary.

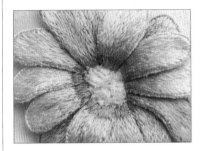

Work daisy centres

1. Outline each oval daisy centre in chain stitch using 2 strands of Soie de Paris Nasturtium. Fill and pad each centre with rows of chain stitch, covering the 3 mm fabric extensions of the petals. No background fabric must be visible between the petals and the yellow centres.

2. Cover the chain stitch padding with French knots in the same thread.

3. To finish off, outline each yellow centre with French knots using 2 strands of Soie de Paris Baobab.

Colour variation

Daisy – Chameleon Shades of Africa Soie de Paris Protea
Centre – Midnight Blue and Egg Yok
The *leaf* colours remain unchanged

Stitch gallery

Counted thread work

Four-sided stitch 1

Four-sided stitch 2

Four-sided stitch 3

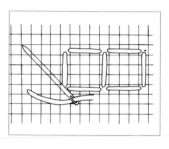

Four-sided stitch 4

Back stitch

Faggot stitch 1

Faggot stitch 2

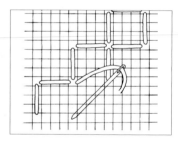

Faggot stitch 3

Blanket stitch eyelet 1

Blanket stitch eyelet 2

Blanket stitch eyelet 3

Blanket stitch eyelet 4

Two-sided Italian cross-stitch 1, 2

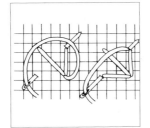

Two-sided Italian cross-stitch, 3. 4

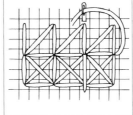

Two-sided Italian cross-stitch, 5

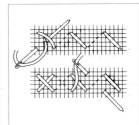

Two-sided cross-stitch 1

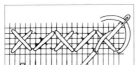
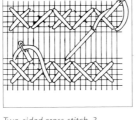

Two-sided cross-stitch 2

Two-sided cross-stitch 3

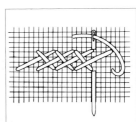

Montenegrin stitch

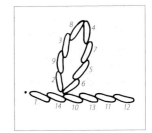

Long-armed cross-stitch

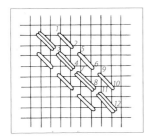

Reversed diagonal faggot stitch

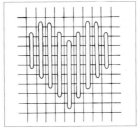

Square eyelet

Satin-stitch heart

Holbein stitch

General stitches

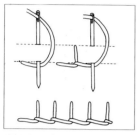

Blanket stitch

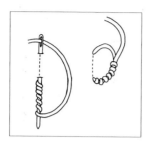

Bullion Knots 1, 2

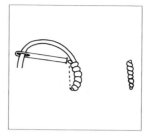

Bullion Knots 3, 4

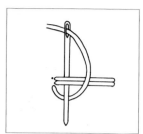

Buttonhole bar 1

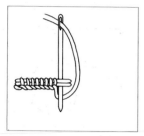

Buttonhole bar 2

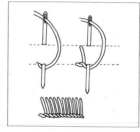

Buttonhole stitch

Chained feather stitch 1, 2

Chained feather stitch 3, 4

Chain stitch

Chevron stitch

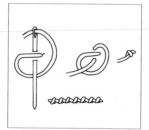

Coral stitch

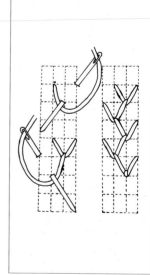

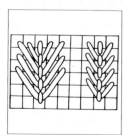

Fly stitch

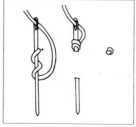

French Knots

Herringbone stitch

Feather stitch

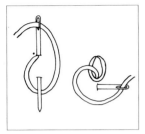

Lazy daisy stitch 1, 2

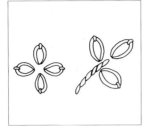

Lazy daisy stitch 3, 4

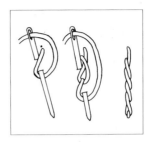

Narrow rope stitch

Outline stitch

Padded satin stitch

Long and short stitch

Spider web

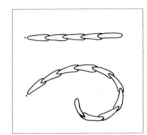

Split stitch

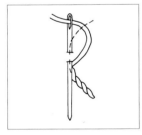

Stem stitch

Straight stitch

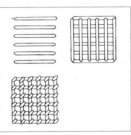

Squared filling

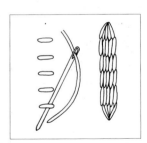

Padded raised stem band

Trellis filling

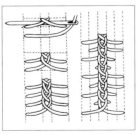

Van Dyke stitch

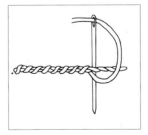

Whipped stem stitch

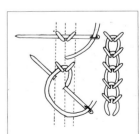

Wheatear stitch

Casalguidi

Double buttonhole bar

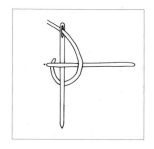

Buttonhole triangle 1

Buttonhole triangle 2

Buttonhole triangle 3

Buttonhole triangle 4

Hardanger

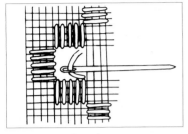

Woven bars 1

Woven bars 2

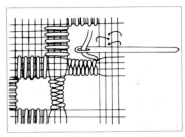

Woven bars 3

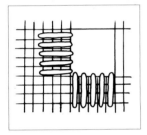

Kloster block

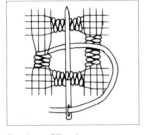

Dove's-eye filling 1

Dove's-eye filling 2

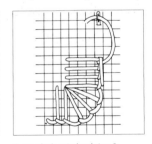

Filet-square filling

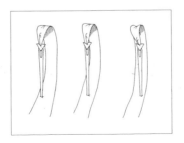

Buttonhole-stitch edging 1

Buttonhole-stitch edging 2

Ribbon embroidery

Couching

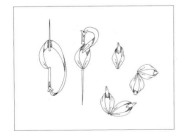

Detached chain/lazy daisy stitch

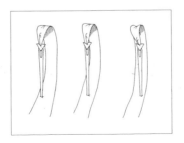

Ribbon stitch

Twisted straight-stitch

Ribbon embroidery

Jacobean embroidery

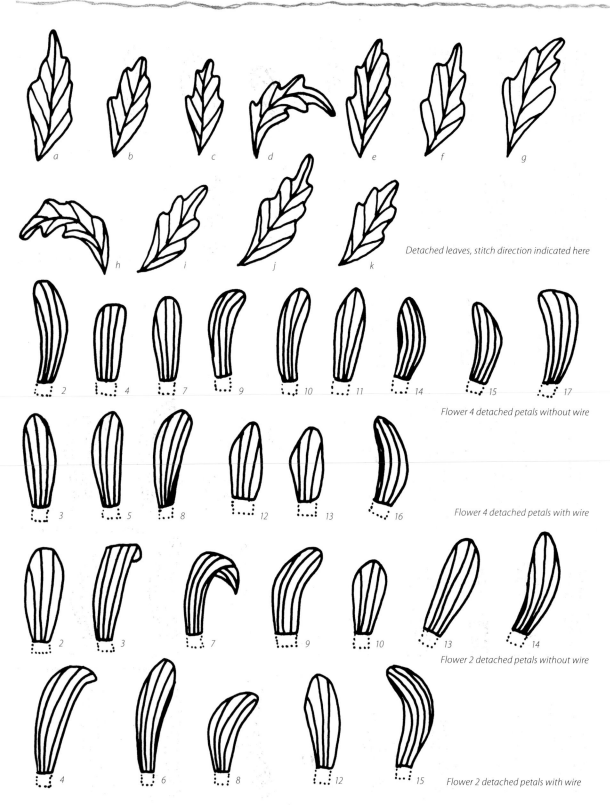

Detached leaves, stitch direction indicated here

Flower 4 detached petals without wire

Flower 4 detached petals with wire

Flower 2 detached petals without wire

Flower 2 detached petals with wire

Stumpwork

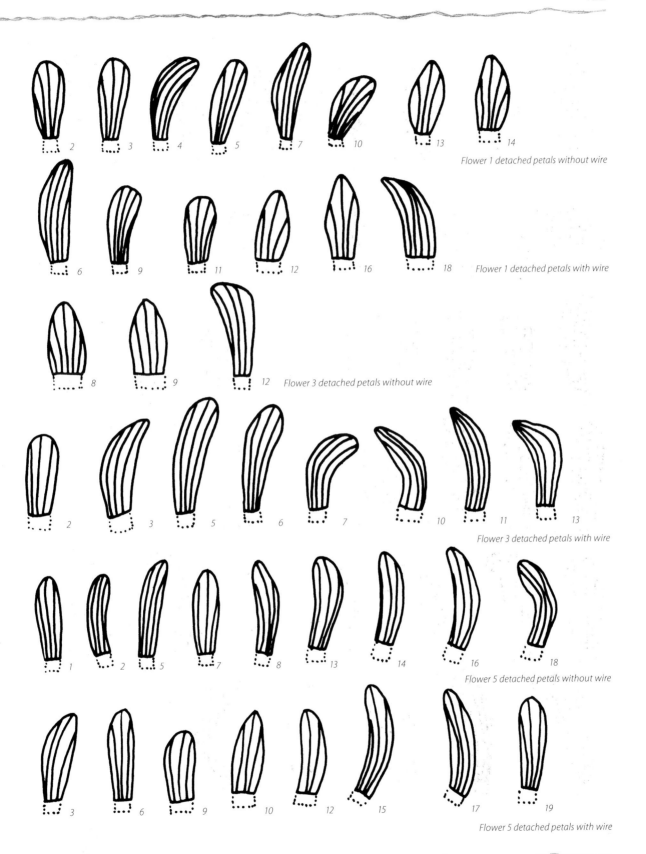

Flower 1 detached petals without wire

Flower 1 detached petals with wire

Flower 3 detached petals without wire

Flower 3 detached petals with wire

Flower 5 detached petals without wire

Flower 5 detached petals with wire

pouch

pocket

Crazy patch

Stumpwork

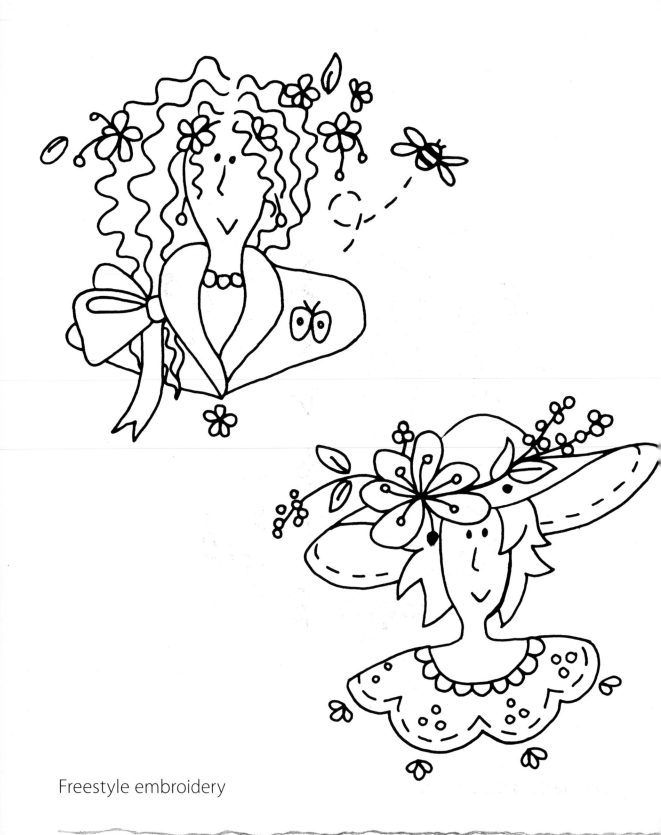

Freestyle embroidery

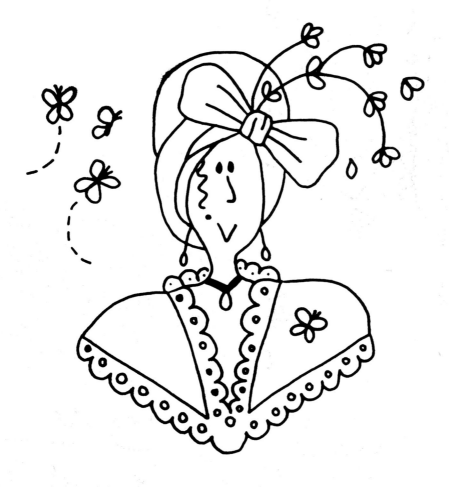

Freestyle embroidery

Bibliography

The Stitches of Creative Embroidery (Schiffer Publications Ltd, Atglen 1987)
Carter, Jill: Beginners Guide to Hardanger (Search Press, Tunbridge Wells 2003)
Carter, Jill: Hardanger Embroidery (Quilters' Resource, Chicago 2000)
Christensen, Jo Ippolito: The Needlepoint Book (Fireside NY, 1976)
Davis, Mildred J: The Art of Crewel Embroidery (Crown Publications, NY 1962)
Eaton Jan: Mary Thomas's Dictionary of Embroidery Stitches (revised edition)
(Brockhampton Press, London 1989)
Franklin, Tracy A: New Ideas in Goldwork (BT Batsford Ltd, London 2002)
Kooler, Donna: Encyclopedia of Needlework (Leisure Arts, Arkansas 2000)
Mitrofanis Effie: Casalguidi Style Linen Embroidery (Kangaroo Press, Australia 1996)
Nichols, Marion: The Encyclopedia of Embroidery Stitches Including Crewel (Dover
Publications, 1974)
Pesel, Louisa F: Historical Designs for Embroidery (BT Batsford Ltd, London 1956)
Warner Pamela: Embroidery, a History (BT Batsford Ltd, London 1991)
Wilkins, Lesley: Beginners Guide to Blackwork (Search Press, Tunbridge Wells 2002)
Wilkins, Lesley: Traditional Blackwork Samplers (Search Press, Tunbridge Wells 2004)

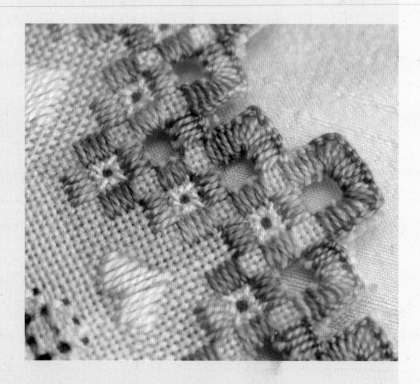